joy in the little things

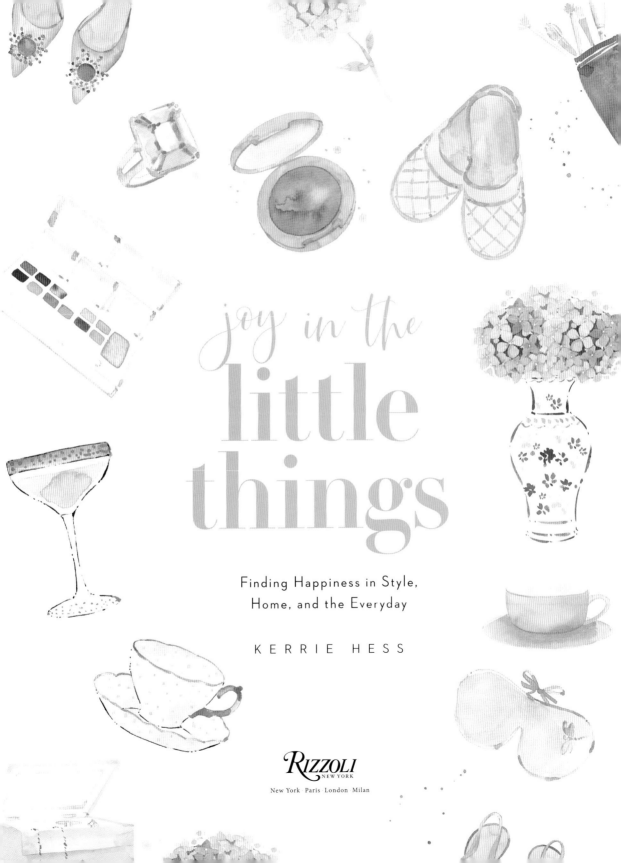

joy in the
little
things

Finding Happiness in Style, Home, and the Everyday

KERRIE HESS

RIZZOLI
NEW YORK

New York Paris London Milan

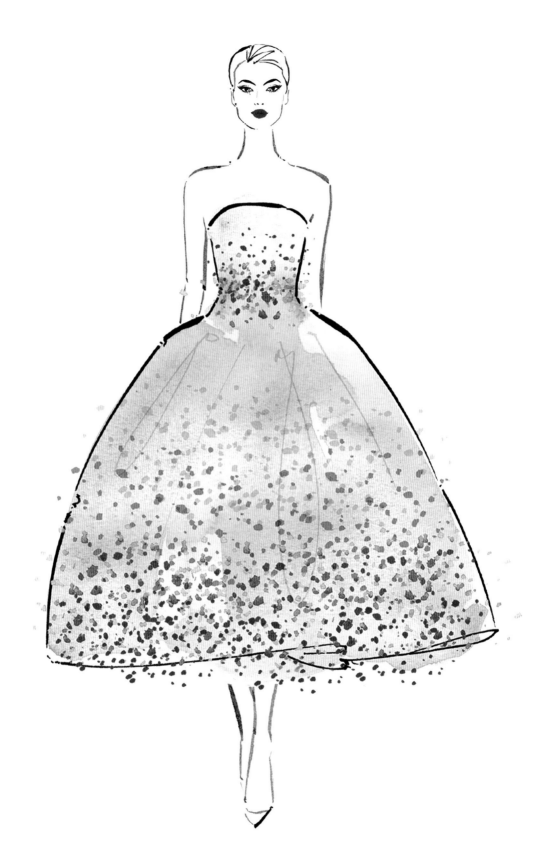

This book is dedicated to my parents,
Jan and Bill Hess. Thank you for
teaching me both that joy is truly
within and how to stop and notice the
small, wonderful moments in life.
To Katrina Lawrence for helping
add a sprinkle of joy to the book
through her delightful editing. Also
to Pete and Marcel, for all of the love,
weekend strolls, movie nights, and
banana bread in the sun. These are
always my favorite moments.

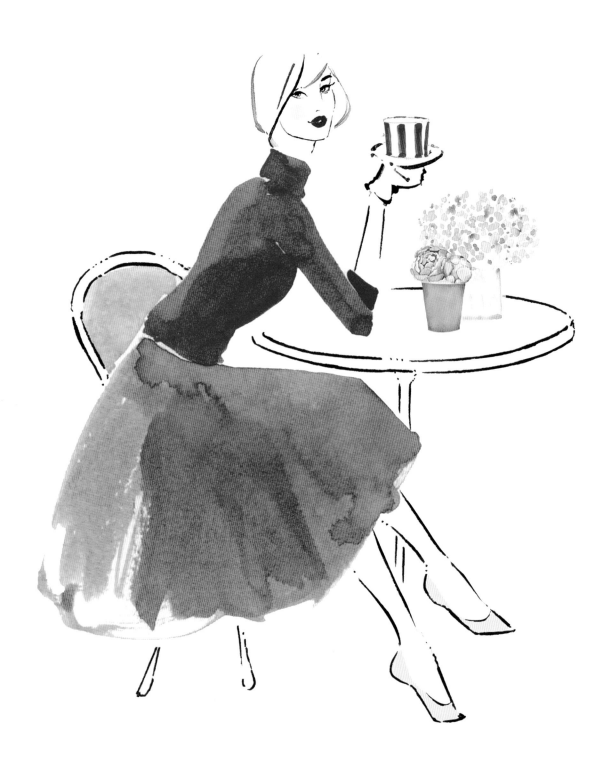

CONTENTS

INTRODUCTION

finding joy

Joy. It's a gorgeous word. Short but sweet, little but loud. It pops like champagne, and it sparkles with a sense of celebration and elation.

The word *joy* is like a bubble of happy memories. It evokes moments of bliss spent with family and friends. I recall childhood holidays at the beach, the salty-sweetness of coconut-scented sunscreen on sandy skin, ice cream dripping down my fingers beneath a shimmering sun…

But what I've come to realize is that joy is more than a thing of the past—it's very much about the present. Joy is being completely in the moment. It's when happiness is so overpowering that it tunes everything else out. You know you're exactly where you need to be.

Joy is what makes life worth living.

I remember an early experience of pure joy when I was seven. I'd begged my mother to let me take weekend art classes. I must have sensed I needed art in my life, although I couldn't have imagined that I would work full-time as an artist when I grew up. From the first session, I was hooked. I painted with a huge smile on my face, even when tackling tricky subjects like hands.

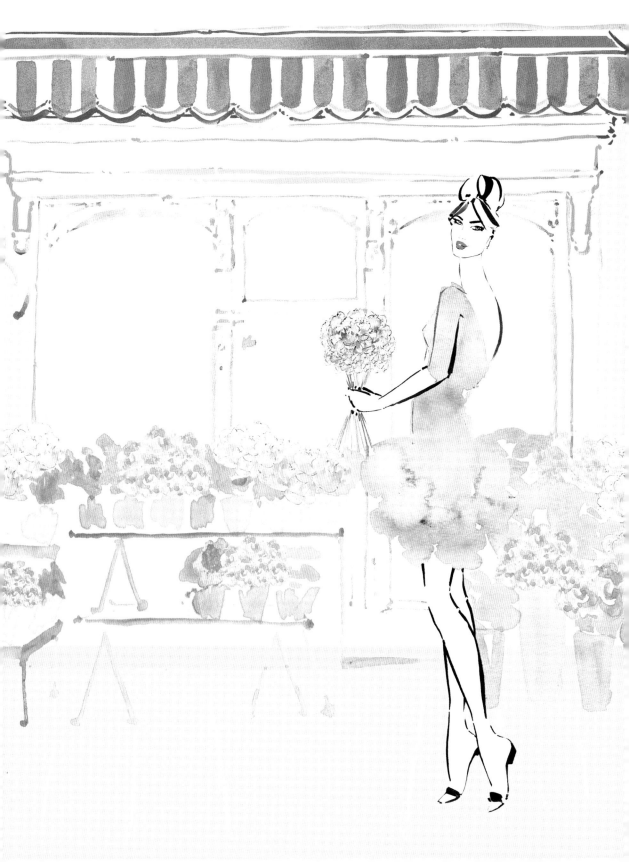

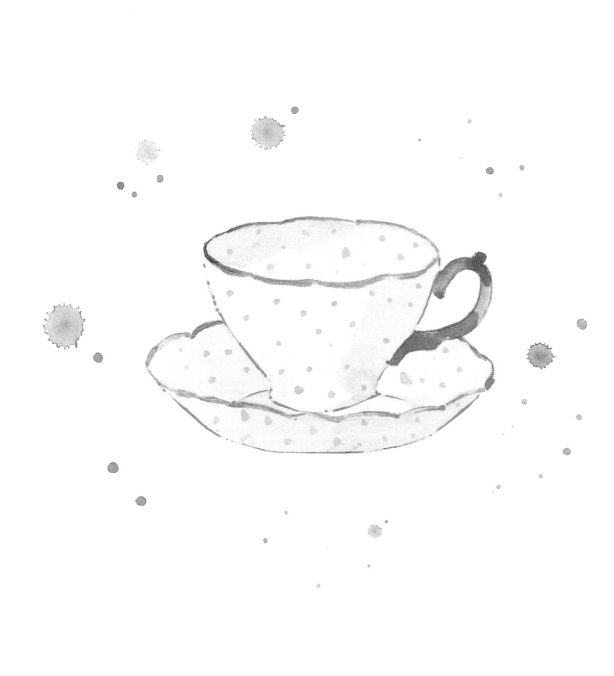

I soon found myself drawn to depicting beautiful things. Some of my first watercolors were of my dolls. I moved onto flowers…then the dresses and shoes of my dreams—long before I even had pocket money! It's funny: looking back I see I was compiling my very first moodboard. Or, perhaps I should say, my joyboard?

Creativity—the exploring of a world of imagination and ideas—is undoubtedly one of the great joys in life, and I'm so thankful that I've been able to parlay my former hobby into a full-time career. But you don't need to be working in a creative field to be creative. Simply do what you love as often as you can. Learn to play the piano! Arrange bouquets of wildflowers! Get started on your memoir! Channel your inner Julia Child! Sign up for a chocolate-making course!

And surround yourself with what you love, too.

It wasn't until I lived in Paris that I came to see it's okay to admit you like beautiful things. Beauty is not superficial there, but rather something to admire, because beauty comes in all forms. There are the museums, of course, brimming with masterpieces, and the honey-colored buildings with their feminine curves and lacy balconies; the perfectly manicured parks with their ponds and parterres, and the shiny boutiques of designer dresses; the elegant boulevards and the elaborate lampposts… But beauty is also in the small details. Here, a chair can be beautiful, so, too, a teacup. Even a platter of cheese can be—*should be!*—pretty.

Soon after starting the daunting task of furnishing and decorating my Paris apartment, I was relieved to realize that I didn't actually need all that much. A lovely sofa here, an occasional table there… Parisian apartments are tiny, for one thing—the closets, too! So quantity is limited by necessity. And, in any case, the French are more tuned in to *quality*. So, you only have one ceiling light

in the whole apartment? Then make it count—and make it a big, beautiful, glittering chandelier!

I've since set up a new home, back in Australia, and I've become rather adept at simplifying and streamlining my life. I own just two sets of bed linens. I don't follow trends; I buy and wear what I find beautiful. But I'm not a minimalist by any stretch—I'm typing this while curled up on a pink sofa opposite a gold-leafed table!

Simplicity need not be boring. I'm fine with having fewer things—as long as they're *special* things. Think: a few framed pieces of art on the wall that make your spirits soar; a collection of trinkets on the side table that make your soul sing; a single rack of shoes that make your heart melt.

It's about cherry-picking. And you always want the glossiest cherries, right?

For the French, joy is also in the small daily rituals. Taking time for a long lunch, going for a mind-clearing stroll, treating yourself to fresh flowers… Shopping for those glossy cherries on your local market street—and also popping into the *fromagerie* and *pâtisserie* while you're at it, for the rest of your evening meal. I relished bringing such rituals into my everyday life, the kind that now, more than ever, feel like a luxury. The simple acts of being outside, slowing down, and toting treasures home have made me feel so connected to the present, so much more in tune with life.

Once I'd moved back to Australia two years later, I was determined to hold on to these daily joys. I was busier than ever with work, but I made sure that my favorite moments of happiness, such as setting aside time for tea, were at the top of every day's to-do list.

When I decided to add "Write a book!" to that to-do list, I didn't know exactly what that book would be at first. I wanted to share my art, of course.

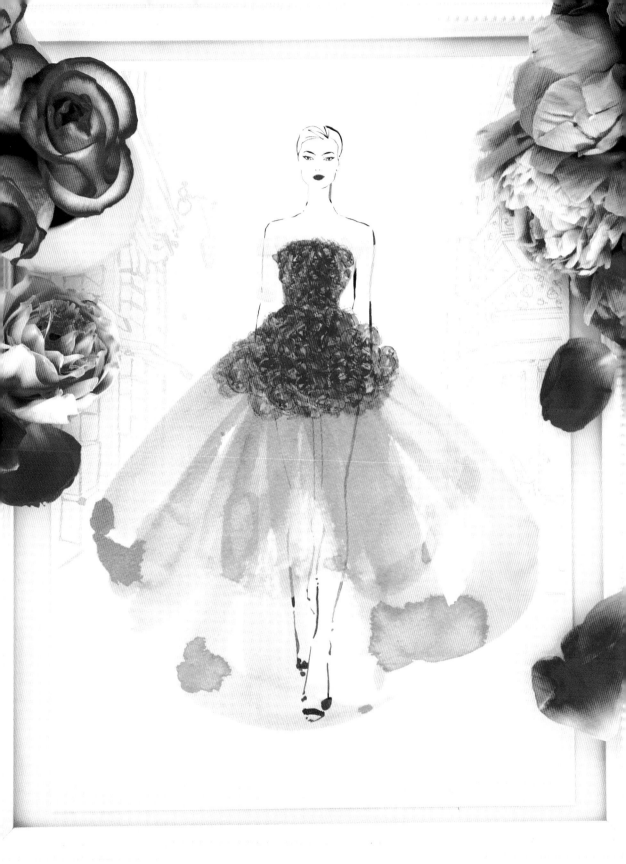

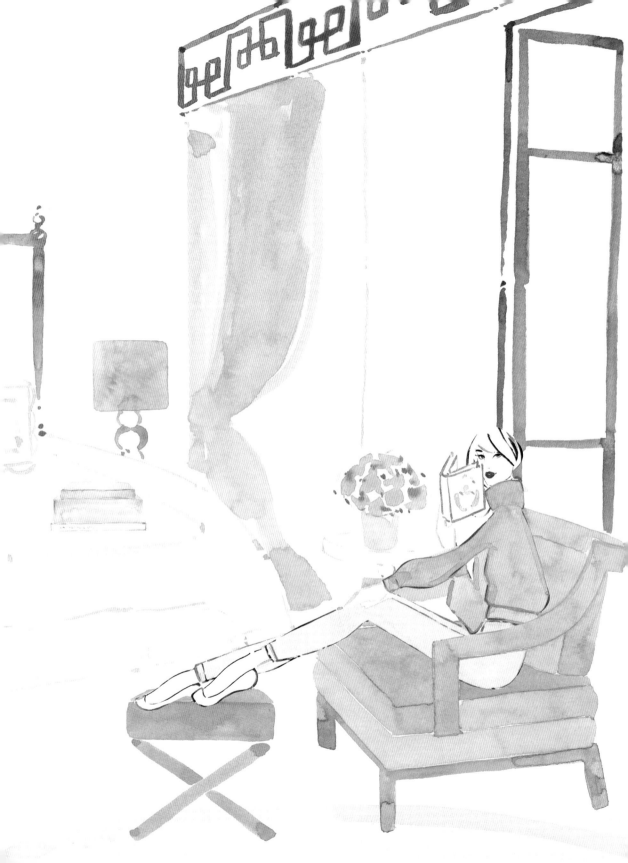

So I started painting, with no particular aim in mind. And I found myself painting things I love, and that I know many others love, too. Cashmere socks, gold-rimmed champagne glasses, pastel macarons…And then it hit me: I wanted to share not only my art, but joy itself. As I wrote and painted in the happy creative chaos of my studio, the world shifted in a way that has changed the daily lives of almost everyone across the globe. When staying inside became the new normal, I realized that the idea of finding joy in the little things actually means so much more now; that finding happiness and delight in your own home, in small rituals and in simple things, has actually replaced what many of us believed we needed in seeking that pure sense of joy. I hope this book is a reminder that we can still find it in the little moments, just as much as we can in the grand and glittering ones.

And naturally, we might have differing ideas of joy…my pink-and-gold teacup might not be your particular cup of tea! But I do hope this book can be a starting point for your own journey toward a greater state of joyfulness, a chance still to dream and fantasize about what's to come. Because seeing beautiful things and imagining all the wonderful experiences you may have in the future can bring you a lovely sense of anticipation, which is its own form of joy. But most of all, I hope this book inspires you to decorate a more delightful world for yourself, and take the time out of your hectic schedule to nurture yourself and your soul with small daily pleasures—those little moments that end up being the big ones in life.

yours in joy,
Kerrie xx

1

joy in

EVERYDAY
LIFE

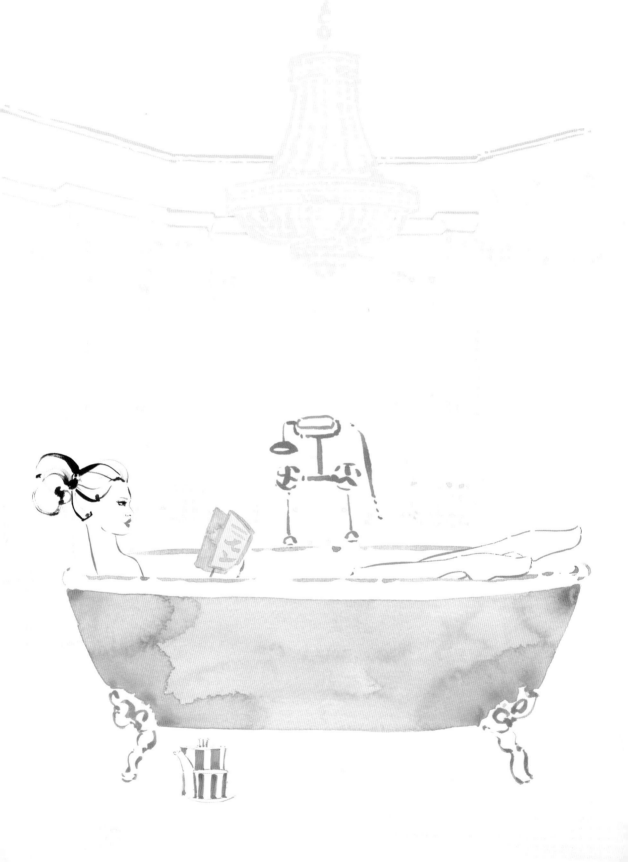

the happiness of
simple pleasures

There's a French expression I love: *La vie est faite de petits bonheurs*. Life is made of small happinesses. The little joys. The simple pleasures. I try to keep that poetic mantra top of mind, especially when said mind is overloaded with work and all of life's other commitments and challenges. Because when you're at your busiest, this is when it's most important to remember the real priorities of life.

It's all too easy to miss the little things when our days are overscheduled with the seemingly big ones—the pressing deadlines, the e-mails to sort, the bills to pay…And we tend to put ourselves last on the to-do list, only to realize at the end of a long week that we forgot to make the time to exercise, cook a favorite dish, soak in a tub of scented water, catch up with friends, or get the hours of sleep we know we need.

Try, instead, to put *you* first—even if this doesn't come easily. Where possible, aim to schedule in some regular exercise that you enjoy, occasional soirees with friends (either in person or virtual), time to be creative, and a routine that allows for enough sleep to feel like the shiny version of yourself each morning. Nobody else will make you complete these personal tasks— you're the boss when it comes to your own happiness! So even if it's only an

hour here, thirty minutes there, commit to scheduling pleasures and musts into your daily timetable.

After all, each of us has the same amount of time—just do the best you can with that time and try to squeeze in moments that bring joy to your soul. It's quality not quantity, as they say! I don't want to spend my years just dreaming about future plans and projects; I also want to find a way to enjoy each day and make it special, to stop and appreciate life. And the best way to do that? There's a hint right there, in that verb: enjoy. It's about finding pleasure within.

The French also have another delight of an expression: *joie de vivre*. According to one dictionary, this means an "exuberant enjoyment of life." And the French, the inventors of such exuberance as champagne and haute couture, sure know how to live life to the glamorous hilt. But what they also know is that life is made of those simpler pleasures, too. Even Coco Chanel said, "The best things in life are free." Okay, so she followed that with "The second-best things are very, very expensive"! But the point is, nothing beats the little, lovely things in life…

As often as possible, give yourself fifteen or thirty minutes in which to do nothing. That's right: nothing! Lie down and let your mind wander to all sorts of lovely places, with no particular aim in mind. You'll find life takes on better clarity in this time (more light-bulb moments!) and that, really, doing "nothing" is actually a big something.

The simple pleasure of…
gratitude and staying present

The mere act of consciously deciding to feel grateful on a regular basis will boost your joy meter more than almost anything else. And the key to unlocking this sense of gratitude, I believe, is finding what connects you both mentally and physically to the present tense. Admittedly, this can be easier said than done! But it's well worth the effort to learn how to be present because true joyfulness is hard to achieve if you're spending too much time in the past or future tenses, in regretting or yearning or fearing. I know I'm definitely my happiest self when I let go of baggage from the past and stop my mind from wandering to a place of worry about the future. And focus on gratitude for what's "right here, right now" helps me achieve this.

So how do you get present-ment? As in: contentment that comes from being in the present moment. Is it by reading a beautiful book? Or nurturing your garden? For me, it's a walk on the beach. I *decide* to let my mind switch off and focus my senses on my surroundings; I take in the sound of the waves, inhale the bracing scent of the ocean, and appreciate the sensation of sand slipping through my toes. If you live near the ocean, feel free to copy my way to present-ment! Just looking out at the abundance of the sea can also remind us to be grateful for nature and of how small we are in the overall scheme of things. At times like these, it can seem easier to let small problems and little stresses go.

There's another simple way to make gratitude a new daily ritual: every evening, when in bed, consciously think of three things you were grateful for that day. Eventually it will become a habit that you do as you fall asleep, rather than worrying about whatever you may not have completed that day or what's coming tomorrow…It's a much more joyful way to drift out of your day!

The simple pleasure of . . . mindfulness

Mindfulness is another lovely way to stay present. There is so much talk about the science behind being mindful but for me it's simply the idea of slowing down and noticing what's around me—that there are birds chirping outside my office window as I write this sentence. How invigorating that sip of coffee is as I type the next words. It's this sense of "noticing" that keeps me attuned to the now, more connected to my day and to life in general.

Some little ways to practice mindfulness include savoring each slow mouthful of a deliciously spiced meal; enjoying the feel of a soft, cool breeze on a summer day; taking time to smell *all* the flowers at your local florist; letting a couple of squares of high-quality chocolate languidly melt away on your tongue; closing your eyes for a few minutes and tuning in to all of the sounds in your area…In short, it's living through all your senses.

The simple pleasure of…
creativity and meditation

I always wanted to be one of those blissfully zen souls who are able to drift away from their daily stresses within a few breaths. But I spent many years attempting—yet dismally failing—to learn the art of meditation. If the same is true for you, don't despair. Joy, as I've said, has a certain zen to it, allowing you to exhale and say *ahhh*…The form of creativity that's right for you has a meditative quality, too.

Before I worked full-time as an artist, I found myself instinctively turning to painting at times of high stress. Everything about the process lulled me into an incredibly peaceful state: choosing from a palette of pretty shades and mixing up new ones (which was lovely color therapy in itself!), whooshing and whirling the pigments over the paper, watching my inner visions come into vibrant life…These spells of creativity were such effective mood enhancers that I eventually realized painting *was* my meditation. It's the thing that stops my mind racing, that connects me body and soul to the present moment, that infuses me with a sense of mindfulness. Sitting in front of a canvas is my lotus position! And the thing that gives me the most joy now is teaching others who are also looking for their own sense of creative meditation through painting.

Even though art is my work, I still schedule an hour every Sunday afternoon, before a new week begins, to paint freely, with no particular purpose in mind. Being creative for the sake of creativity is such a mentally and emotionally enriching process. If, like me, you have trouble quieting a busy mind though traditional meditation, try something creative instead. It might be painting, but it could just as effectively be baking, knitting, crafting, tinkering away at the piano…Find the activity into which you can immerse yourself, not only with your mind, but with your heart and soul, too, and your life will become immeasurably more joyful.

The simple pleasure of…
rest and rejuvenation

Many years ago I begrudgingly agreed to attend a group life-coaching session hosted by one of my clients. I was late to arrive, a ball of stress wound tight after a difficult day, and not in the frame of mind where I thought a life coach could solve any of my problems. Within minutes, I was shocked to find myself sharing my emotions with a group of strangers. I complained of constantly feeling busy and tired, continually rushing but always late—exactly as I had been that evening!

The very clever life coach listened to my words, paused for a moment, and then politely explained to me that the only thing in common with every job I had on my plate—the cause of my hurried, harried state—was that *I* had agreed to all of them.

Talk about a light-bulb moment. This one was megawatt for me. It all became embarrassingly clear: for years I had overscheduled myself, saying yes to all of the things I *wanted* to do, rather than choosing the things that I *could* do in a certain amount of time. I was the reason for my own constant frazzlement—and, in turn, my lack of joy!

That's when I made the decision to start saying no to about 20 percent more of the corporate jobs I wanted to do but knew I couldn't realistically fit in. As a result, I would enjoy the ones I did accept, and keep enough wiggle room in my life to avoid burning out. I realized that I was the only person who could do this for me. *And it completely changed my life*. If you are also someone who tends to overschedule your own time, there really is joy in "the power of no" sometimes…always said politely, of course!

I swear, JOMO (Joy of Missing Out) is a thing! Now, when I know my schedule is full and I have to turn down a project or a corporate event, I feel a sense of blissful relief, knowing that I have prioritized my sanity. Doing this is how I have been able to build time in my life for rest and rejuvenation,

time for the occasional afternoon nap on weekends, time to go for a walk on a weekday evening or play a card game with my family, rather than burning the midnight oil at my desk. And time to go to bed early enough to get the amount of sleep I know my body craves. Always listen to your instinct if it's quietly saying "no" to a project or an invitation that you know deep down you just can't fit in. Some time for stillness and creativity is always time well spent.

Books are a tried-and-true form
of relaxation for so many of us.
Look at your books as an art form,
and display them as such,
stacking them in interesting ways,
or color coding the spines to add
a vibrant energy to your living room
or to create a soothing rhythm on the
shelves in your bedroom.

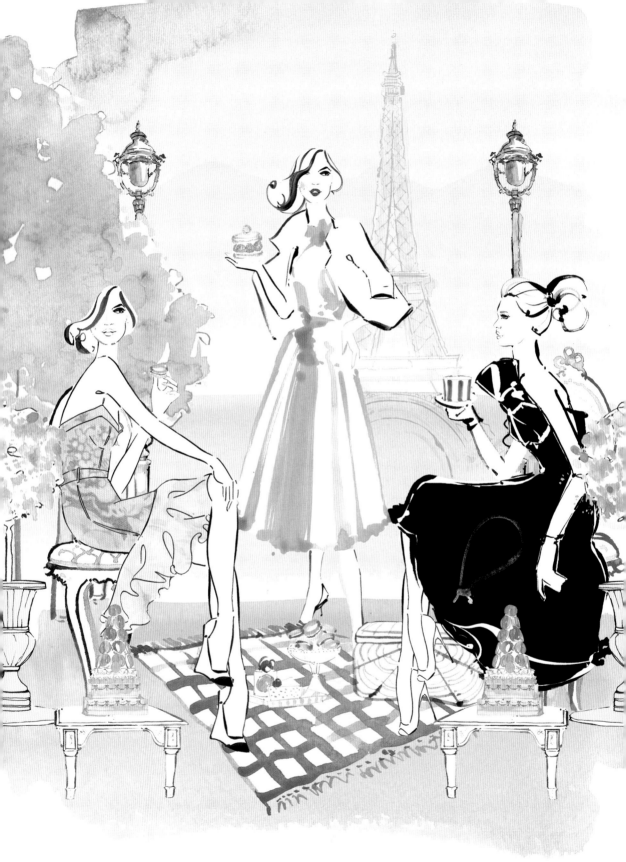

The simple pleasure of…
connections

It's okay to unashamedly enjoy your own company just as much as time with others. As someone at the quieter end of the introvert-extrovert scale, I generally prefer time to myself rather than time in large groups. I also know that more intimate catch-ups with my closest friends never fail to light up my soul.

Whether your ideal is going out every second night or every second week, socializing is a crucial component of contentment. I know when I am too busy with work and unable to see or speak with my friends for a few weeks, I feel a little adrift. On the other hand, too much socializing in one week (even if it's virtual rendezvous!) can leave me drained and overwhelmed.

Find your own perfect balance of connecting to others, and you'll feel a wonderful connectivity to something bigger. A picnic with girlfriends will give you a sense of togetherness and a chance to appreciate nature at the same time. A joyful duo! Light exercise with a friend will provide mood-boosting endorphins and allows you to share fresh new perspectives on the various challenges in your lives. And surely listening to someone else's problems also reminds us that we're not alone in our struggles.

If you're in a relationship and can't remember the last time you made a little effort in the romance department, perhaps it's time to get back to dating! Serious dating—the dress-up-and-talk-about-things-other-than-kids-or-renovation kind. Take turns booking somewhere new, or head to a scenic spot for a twilight picnic; even if you also need to book a babysitter or a trusted friend whom you won't forget to spoil later for the favor (those spontaneous pre-children days all too quickly become a distant memory!). Wear something that makes you feel like your sparkliest self, and give yourself and your love a chance to discuss your *dreams* rather than any humdrum reality. Even if your date is on your own candlelit balcony, it's a chance to remind yourselves why you fell in love, before everything else came along.

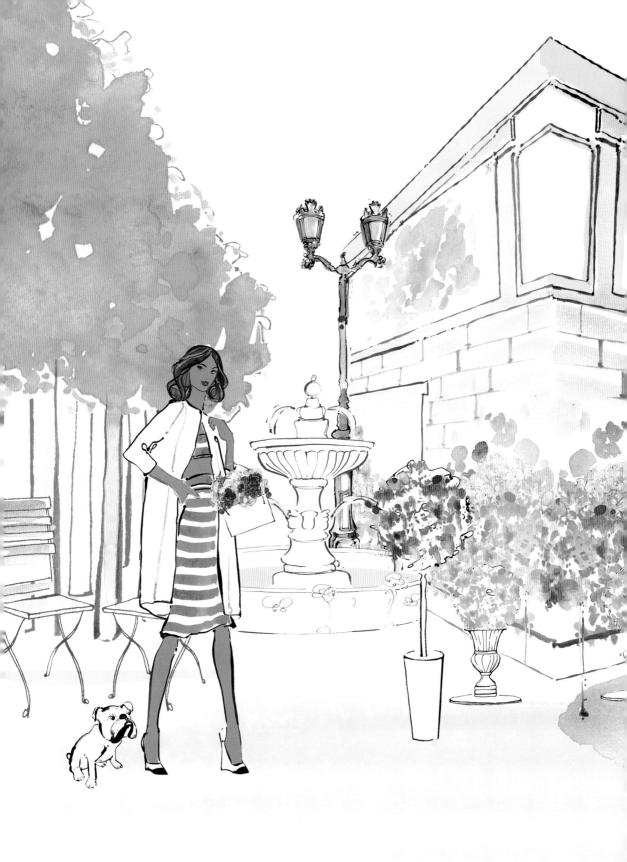

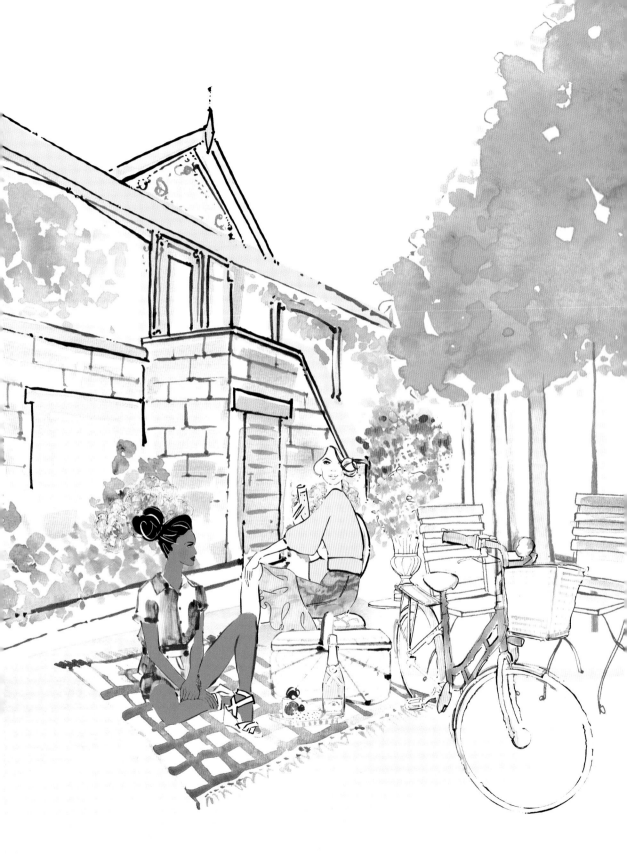

The simple pleasure of … movement

There is no greater stress reliever than moving more—literally shaking off anxieties or wringing out your worries. And there's a reason for the expression "meditation in motion": physical movement is wonderful for realigning the senses, making you feel calm and present. And before you think I'm going to recommend a three-hour high-intensity sweat session, the genius thing about exercise is that it can be so simple that it barely feels like exercise at all. Although if a three-hour high-intensity sweat session is your idea of fun, I salute you!

We all differ in the kind of movement that makes us feel happiest in our own skin. The key is to figure out your own exercise lane, and stick to it by scheduling movement into your calendar regularly and often. Think of it as an appointment with your own well-being!

If you've neglected fitness for a while, get back into it with baby steps; start small with a ten-minute stroll or stretch per day. This way you're much more likely to follow through. When you're ready, you can increase the number of sessions, their length, or their intensity—or all of the above! Just remember that the point is regularity. According to the experts, it only takes ten repetitions to form a habit.

Moving a little but often also tends to be better than a single hard-core session per week. This, I have to admit, pleases me, as I am one of those people who are generally averse to sweatiness. So I schedule in easy daily movement rituals (ten minutes of stretching in the morning; a fifteen-minute stroll in the early evening) as well as more involved weekly sessions (a couple of yoga classes). I've found that this is what gives my body and mind a sense of calm, balance, and—yes—joy.

It took me a few months to come up with my ultimate fitness routine. I had to give myself permission to prioritize myself each day. And I also had to change my mindset from "exercise is hard" to "exercise is time for me." Try this shift of thinking and the feeling of enjoying exercise may come more naturally. Exercise for pleasure, not pain, and you will want to do it again and again!

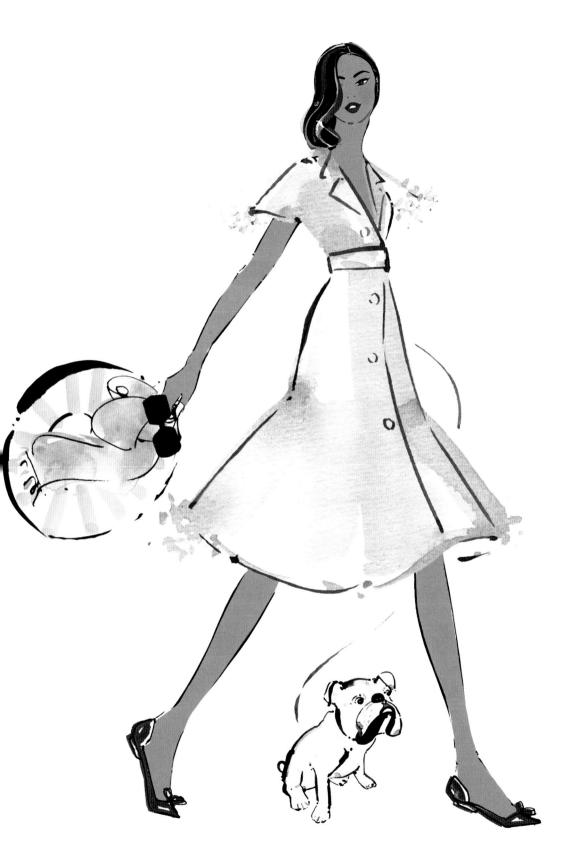

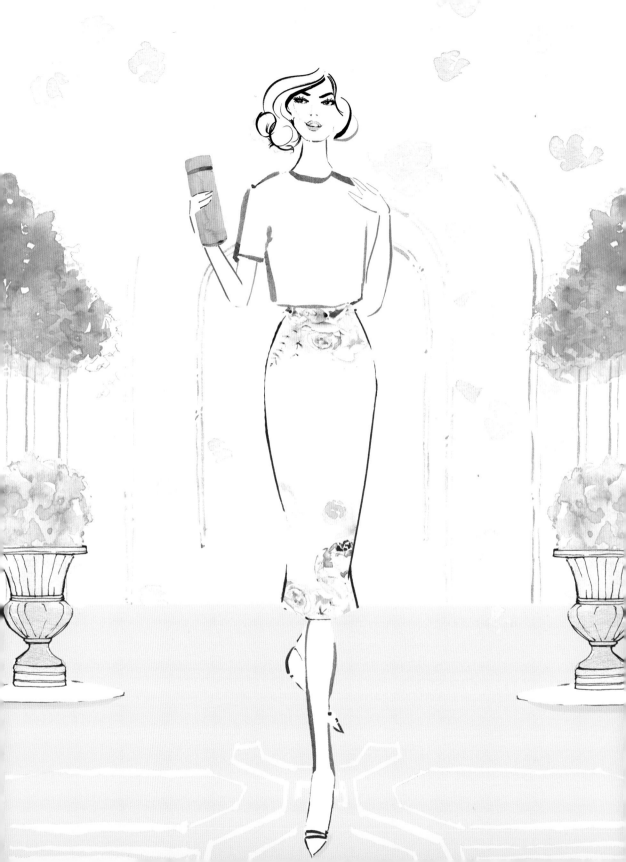

daily rituals
that delight

As an artist I have been lucky to travel to some amazing and glamorous destinations for work. It's a hard job but somebody…Just kidding! I'm incredibly grateful for these experiences. But the most wonderful thing to have come out of all this travel is the realization that I am actually happiest at home, as a creature of habit, and that some of the simplest daily rituals infuse me with a deep sense of joy.

Even those intrepid types who travel farther and wider than I do will probably relate. We humans arc trained to love ritual early on; as babies, we're cosseted with routine, because it's what makes us feel safe and secure. It's little surprise that, no matter where life ends up taking us, so many of us feel most grounded when we can schedule those rites and rituals that make us feel, well, like us.

We all have different habits of happiness. Sipping a certain tea from a certain cup every morning…singing in the shower…doing a face mask on a Wednesday night and a hair mask on a Thursday night…reading thirty pages of a bodice-ripping historical novel every evening…painting your toenails every Sunday morning.…The key is to incorporate moments devoted to your favorite little pleasures into your everyday life. Don't think you have to wait until you're on vacation to treat or care for yourself—you deserve joy every single day!

In need of more inspiration? Turn the page for a few small joyful rituals to try…

In the Morning:

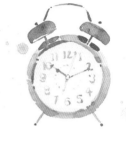

- Wake up twenty minutes earlier than your usual time and stretch to your favorite music.

- Before you grab your phone to check e-mails, stop and think of five things you are grateful for. As I've noted above, gratitude is an essential element of a happier life. In this sense you are choosing yourself rather than work as your first priority of the day.

- Stop for fifteen to thirty minutes to enjoy a coffee, tea, or your preferred drink outdoors, to flip through a newspaper, or to go for a stroll. Taking a break from screens will clear your head, soothe your eyes, and reconnect you to the present.

In the Evening:

- Go for a walk before dinner, to the park, or to any place you find relaxing.
- Make cooking enjoyable. Turn on music you love, pour yourself a glass of wine, and concoct your favorite dish. (I always find cooking therapeutic when I make the effort to turn it into a pleasure rather than a chore, and when the focus required allows me to switch off from everything else.)

- Revel in a candlelit bubble bath, then slip into some silky pajamas and get lost in a good book, be it of the printed or audio kind.

- Before you drift off to sleep, make a mental list of three specific things that made you smile. A second daily dose of gratitude will help offset the moments that didn't work out as planned.

Think of the songs that make
your heart beat faster, that make
you want to sing into your hairbrush
or dance like nobody is watching!
Now compile them in a playlist
in your music player…and why not
name the collection "Joylist"?!
Make this your life soundtrack,
or the go-to playlist every time you
need a happiness boost.

Sweet
SB1-160

WATERCOLOUR
Eraldo di Paolo

Muted Musk
B150-C

Little things that make your heart sing

Yes, many of the best things in life are free…but sometimes it's okay to *buy* beautiful things, too! I have a hunch that you might also have a hankering for pretty things…we humans can't help being hardwired to gravitate toward beauty. Studies show that even babies are instinctively drawn to what they find aesthetically pleasing. And we live in a visual world, one of so much gorgeous art and artisanal creativity…so why fight an urge to appreciate beautiful things?

And you don't have to justify what you like, either. Beauty is always in the eye of the beholder, of course! I've compiled my love list below, but you can enhance your life with any items that, quite simply, make you go *ahhh*…

Pretty teacups

I swear that a cup of tea, even if it's just a regular English Breakfast brew, tastes better when it's sipped from a dainty teacup! There are so many gorgeous ones around at all price points—you can always find old-world floral porcelain cups at an antiques store—and they're a joy to collect. Always have a favorite cup (mine is currently pink with polka dots) on hand, to make your afternoon tea break that much more special.

Fresh flowers

Waking up to a room scented with fresh flowers (of any variety) never fails to make my heart flutter. I also love having a vase of blooms on my desk, where they inspire me while I'm working. I don't get around to filling my home with flowers every week, but I try to buy a bouquet as often as possible, because it's such a lovely way of infusing the home with color and scent.

Silk pajamas

There are out-on-the-town types and then there are homebodies. I definitely fall into the latter category! Either way, a beautiful set of fine cotton or silk pajamas (in other words, the opposite of an old T-shirt and sweatpants!) will make lounging around seem like a special treat. Add a silk robe and fluffy slippers to take it to an even more luxurious level.

Fine cotton sheets

We spend about one-third of our lives in bed, which is definitely
a justification for splurging on sumptuous bedding! Whether
they're Egyptian cotton or simply the best quality you can afford,
beautiful sheets are without a doubt one of life's pleasures. I
only own two sets of sheets, both at 1,000 thread count and
100 percent cotton. They were the very best I could buy, and
choosing quality over quantity has not only lightened up the
linen cupboard, but also ensured that the simple act of going to
bed now always feels like a luxury.

Picnics

A picnic in summer is surely one definition of
happiness: Feasting on delicious antipasti treats,
smothering a crusty-yet-soft baguette with gooey
cheese, sipping crisp rosé . . . And all this served up
on a red-and-white checkered blanket in a pretty
alfresco setting . . . Give me that over a fancy five-star
restaurant any day!

French macarons

French macarons are the little pastel jewels of the pastry
world. I used to live only five minutes from Ladurée on the
Champs-Élysées, and quickly fell in love with the rose and
salted caramel macarons. Fortunately macarons are now
widely available beyond the borders of Paris, in a head-
spinning array of colors and flavors. A perfect addition to
your afternoon tea ritual, they're almost too pretty to eat . . .
but only almost!

Cashmere socks

Short of a deluxe pedicure, little is more nurturing for
hardworking feet than a pair of plush socks. Cashmere
wraps tootsies in a cocoon of comfort, and is particularly
ideal for cozy nights in or during long-haul flights.

Champagne coupe glasses

Sure, champagne is special no matter what, but drinking it
from a saucer glass rather than a flute just seems so much more
glamorous. Think of the "coupe" as the Marilyn Monroe of
glassware! We tend to hold this style of glass differently—more
delicately. And the actual drinking is different, too—the bubbles
tickle your nose, and the champagne seems so much more
aromatic. You can usually find such coupes in antiques stores,
and it doesn't even matter if you can't buy a set—a collection of
mismatched etched-crystal and gold-rimmed glasses on a bar cart
or a sideboard not only looks whimsically eclectic but also like a
glamorous still life!

Rosé champagne

I adore all the hues of champagne, from the pale and
almost pearlescent to the glittering golds...but there's
something about pink champagne that makes me swoon...
Maybe it's because it gives you the chance to see the world
through a rose-tinted glass!

Sugar cubes

I try not to sweeten my tea but when I do, I love using a sugar cube. That's another habit I picked up in France, where sugar cubes are one of those "just because" things that make life even nicer.

Handmade chocolate

When I arrived in France I was so surprised at the number of *pâtisseries* and *chocolateries*. (There's practically one on every corner in every single arrondissement!) In no time, I started to buy my treats like the locals. After all, a petite packet of handmade dark chocolate is far more pleasurable than a family-sized block from the supermarket. If chocolate is your weakness (as it is mine), buy the highest-quality chocolate you can find (dark is healthier for you, with its antioxidant power, and more satisfying if you have the taste for it) and enjoy a small number of squares at a time. Stop everything else while you savor each melting morsel...This is the French way to enjoy chocolate every day.

Silk eye mask

There's a certain guilty pleasure in an afternoon nap. Not that we should feel that much guilt since it's an effective way to boost lagging energy levels. I always use a silk eye mask to block out the light—and because it feels so soft and nurturing on the skin. I also love to slip one on during a long flight—it's a lovely touch of first class no matter where you're seated!

Scented candles

Setting the scene with my favorite scented candle is a signal to my brain that I've switched off from work for the day. Just add comfy clothes for lounging about and a glass of wine! A scented candle is also the best accompaniment to a bubble bath after one of those days when absolutely everything seems to have gone wrong (we all have them!).

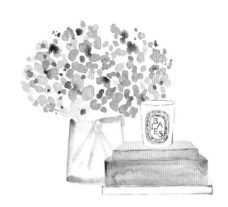

Lace lingerie

Whether happily single or dating the partner of our dreams, we all deserve one or two special sets of underwear. Some time ago I bought the most gorgeous silk and lace smalls in Paris from Fifi Chachnil, beautifully wrapped in tissue, just for myself. Wear them sometimes for no reason at all…

Afternoon naps

Even if you can only squeeze in an occasional nap on the weekend, it's a delightful chance for your body to rest and recharge. Just twenty minutes to close your eyes and let your mind drift and your body relax is truly one of life's little luxuries.

It's important to know
what's going on in the wider
world, but when the headlines
seem full of woe and worry,
search out the good news stories
and share them on social media
to help balance all the
negativity out there.

Everyday life: an artist's view

Throughout history artists have painted and sketched the simple beauty of ordinary objects: an arrangement of flowers, a bowl filled with ripe and colorful fruit, shelves and tables scattered with a variety of striking yet also perfectly mundane objects, from eggs to bowls to books.

This genre is known as still life, a term that I love, because focusing in on the small things, the finer details, seems to slow time down, to make you stop and appreciate what is right in front of you.

Maybe that's why we may love to amass those teacups or pillows. They remind us that there's beauty in daily life—art in the ordinary.

These small treasures are ideal for creating little installations of visual joy in your home. Try placing a cluster of vintage cups on the mantel, or running a line of vases down the middle of the dining table. Or mix and match favorite items for a modern vignette: stack your fashion books high, and pop a candle on top.

If you want to indulge your creative spirit even more, try re-creating your still-life arrangement on paper! You'll just need a few watercolor paints, some sheets of paper, and a couple of basic round-tipped brushes.

Calming and creative ideas

Visit your local market for fresh flowers that will brighten your living space or office. Choose a ready-to-go bouquet or, better yet, a selection of individual blooms, so that you can customize an arrangement to your fancy. Make sure to cut the ends of each stem on an angle before placing them in a vase—this will allow in more water and prolong the life of your flowers.

Another great everyday creative task: challenge yourself to cook something completely new. Leaf through your recipe books until inspiration strikes, or pick a random page and go from there. Take your favorite basket to buy all the ingredients, and give yourself the rest of the day to savor the process of concocting a new taste sensation. Optional extra: a glass of rosé to help things along!

2

joy in
HOME

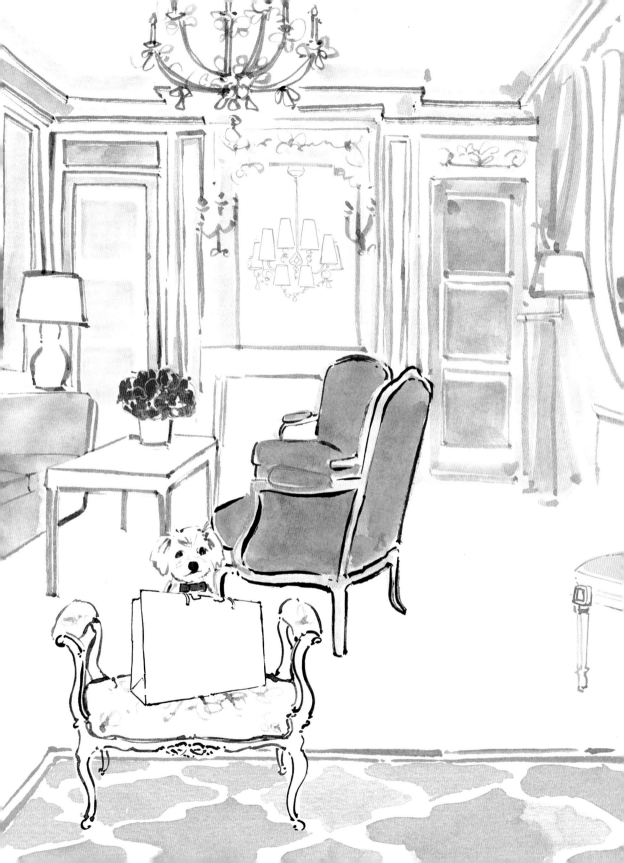

home: where your heart is

There is such comfort in loving the place you call home—your own private sanctuary. Perhaps you are just like me: someone who savors a quiet night in over being social. Perhaps you work from home, as more of us do these days, so your perfect abode nurtures your mind as well as body and soul. Or maybe you revel in the feeling of having your evenings and weekends to relax in the place that makes you feel calm, joyful, and inspired—your little nook in an ever-busy world. Your home sweet home.

And even if home is also your office, it should be a place where you can revive and recharge after a workday goes pear-shaped. It's where your puppy is, ready for endless cuddles. Where you might have a loved one cooking your favorite meal to make your day. Or where you might have a delightful evening to yourself filled with a bubble bath and face mask. Where you might watch a glowing summer sunset from your balcony, or warm up in winter with cozy cashmere blankets and steaming hot chocolate. It's where the memories of reading nursery rhymes to your little ones are made, or the place where plans for your next life adventure with a best friend are plotted out. Home is where many of your daily rituals of joy happen. Where your mind and body can find a renewed sense of zen, despite the most hectic life, job, and schedule.

Home is also an extension of you and an expression of your individuality. It's a place where you can create some spaces uniquely for yourself and your own needs and desires, a space that you can fill with things that enhance your life in ways both practical and pretty. (To keep them organized, follow the Display vs. Store method.*) You can sprinkle your personality in every room. You might be a quiet minimalist living in a softness of earthy tones, or a passionate maximalist surrounded by bold color and patterns. The choice is yours!

As an introvert, I always regather my energy at home. And as a creative soul, I find that my home is a reflection of my state of well-being at that moment. When my home is uncluttered and organized but also inspiring and creative, I know I am in a happy headspace.

As with fashion, a home need not be dripping in designer pieces to inspire you. A sense of pride in what you already own and cherish is key, combined with a calm, creative, and joyful reflection of yourself; these are the elements of a happy home.

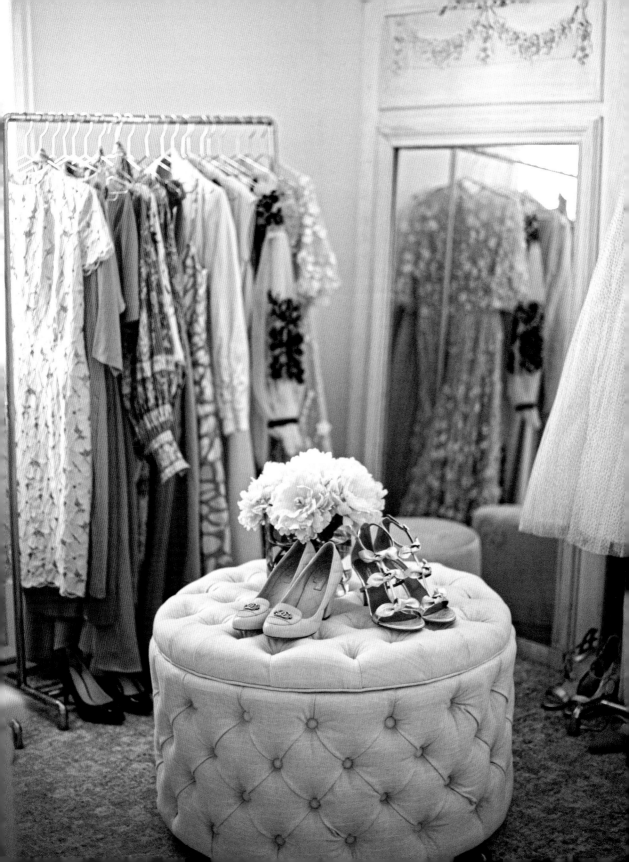

Display vs. Store

Anyone who has read Marie Kondo's books will appreciate the wisdom of organizing a home by storing the things that are unattractive but entirely useful, while displaying those belongings that delight our eyes.

In general, the fewer things we own, the easier this theory is to live by. Make the decision to go through your house room by room, at least twice a year, to declutter and ditch the items you no longer need. Kondo's advice of thanking things before you part with them makes it notably easier to let go of what you've kept way too long, what's taking up precious breathing space in your home. Every item you give away is a small step toward creating a more organized life.

Tackle one room at a time to avoid feeling overwhelmed by the task. And celebrate your hard work after every room cleansed!

Designing a living space you love

Part of feeling joyful at home is to love the space you've created for yourself. You want to step through your door and experience that *ahhh* sensation. It's a question of feeling at home not only in your house or apartment, but also feeling at home in yourself. Ideally, your home will reflect who you are. These days you don't need a designer budget to achieve a great interior design style—there are so many stores and online marketplaces that help you find the pieces that together will express the authentic *you*.

Here are some ways to enhance your home style:

Decide on the theme: To figure out what kind of home will make you the most content, start by thinking about your favorite thing in life. Is it lounging at the beach? Vacationing in Paris or Positano? It might be the Hollywood Golden Age. Or perhaps a particular style of music. The list is endless. Draw in elements that would sprinkle a sense of joy in your home. A Hollywood Regency decorating style might suit you if you love classic cinema of the 1950s. Or whitewashed furniture and linen slipcovers might be perfect for you if you're a beach lover (even if you live nowhere near the ocean!). Dramatic chandeliers and gilt-trimmed mirrors are lovely if you're inspired by the romantic City of Light….

Home in on the details: Next, look through interiors magazines and tear out images of decor and furniture that speak to you. Don't analyze anything yet! Once you have a pile of inspirations, you'll see patterns emerge of the colors and styles you're instinctively attracted to.

Bring it all together: Over the next few weeks, do the same collection process on Pinterest, too. Start a "Dream Home" board (which you can make private if you want!) and look at the patterns, themes, and colors that come up time and time again. These are the elements to bring into your own space.

inspiring home hues

When decorating my office, I pinned so many images of pink couches and gallery walls of illustrations that it was clear these had to be part of my studio. For the rest of my home I am always attracted to simpler lines in monochromatic tones. I crave a sense of harmony after a long day of color and creativity.

Here are some of the home color schemes I find inspiring...

Black, white, and gray

A monochromatic home is sleek, chic, modernist, and mature. Neutral tones can also be soft and relaxing (I think that's the likely reason this is the palette for most of my house, especially my bedroom, where switching off from work is so important). Add in metallics like silver or brushed gold for a little drama.

Navy blue and white

Evoking elements of a European summer, this classic pairing is soothing and clean. Don't be fooled by its apparent simplicity—it subtly hints at exotic notes of seaside Greece and classic Chinese pottery. Layer in texture with stripes and patterns in various shades of ever-stylish blue and white.

Pink and rose gold

Modern, yet playful and pretty—the perfect office or dressing room scheme for "a room of one's own." Look for pinks that are muted and dusty for a grown-up take. Rose gold adds a hint of warm, sophisticated shine.

Pink, gray, and white

A dreamy Parisian palette. Just add wall detailing such as molding and sconces, sparkling pendant lamps, and—if the budget allows—parquet flooring. With a color palette like this that is so feminine, a few masculine pieces of furniture in the room (even in white) will help with balance. *Parfait*!

Neutrals or all-white

Think seaside Hamptons vibes. Both relaxed and sophisticated at the same time, it's the perfect color arrangement for a vacation house, or for anyone who likes a calm and uncluttered feeling at home. Just make sure that some pieces in your space have different texture to add some interest in an otherwise simple array of shades.

Dove gray, duck egg blue, and white

Fill your home with a charming countryside palette of dove gray and duck egg blue. Trims of white molding and furniture will add a soft structure to the muted and calming tones. Pair them with touches of brushed silver fixtures, a white farmhouse sink, and curtains in the same hues for an elegant take on cottage style.

the joy of taking your time

Once you have discovered your most loved decor style, assess whether any of the "bones" of the home could or should be refreshed (and if it's the right time to splurge on this kind of update). For example, you might be considering a change of flooring or wall color. If the structure of your space is fine, try out smaller updates with tweaks to furniture or accessories. Soft furnishings are the simplest and least expensive things to upgrade! (Etsy is a great place to look if you want to find unique, custom-made pieces, like cushions and lampshades—as well as a chance to support small businesses.)

Remember: there is never a rush on decorating. The most beautiful and inspiring spaces are rarely put together in a day, or in one style alone.

Rather, they're created lovingly, one joy-inducing piece at a time… The real key is to enjoy the process! Fashioning your home is a project that will evolve over the years rather than have a specific end point.

Spending the day at home again?
Why not stay in your pajamas
all day? It's so good for the soul!
The trick to feeling more lounge lizard
than sloth is to change from your
overnight pajamas into a silky clean
pair after showering. You might feel
guilty for the indulgence—but in the
best possible way!

Creating an inspiring home office

For anyone who works from home (which is a lot more of us now!), it's especially important to enjoy the space where you spend so many hours. Start by making sure it's as separate as it can be from your living space—even if this is only with the division of a folding screen or a decorated bookshelf. At the very least, a special rug that marks out your office will allow you to "step into" your work space, and out of your living area, both physically and mentally. Set yourself up with as much natural light as possible, and decorate with tones and items that inspire and uplift you.

I'm lucky to always work from home, which means my office doubles as my me-space. I can decorate and personalize it to my heart's content, and I can truly be myself there: shoes off, hair up, painting away. If you also have a home office, remember that it's not only a place where you toil; look at it as your sanctuary, where you can be yourself, and also run your own business.

Here are some ideas for designing a place where you enjoy working each day even more:

- LIGHTING AND FLOORING: If your space is lacking in natural light, bright white walls and pale floors will help bounce more light into it.

- COLOR: Choose shades for your office that put you in a productive frame of mind. Since dusty pink is a signature color for my own brand, I even painted my office door pink! Just walking through this door from the outside sets my mood in creative work mode.

- FURNITURE AND FURNISHINGS: Consider including some eclectic pieces for your home office that you would not likely see in a traditional work space. An art nouveau pendant lamp, a gold cabinet with accent lampshades, or a Parisian-style chaise longue…Unexpected elements enhance the creative mood of a room.

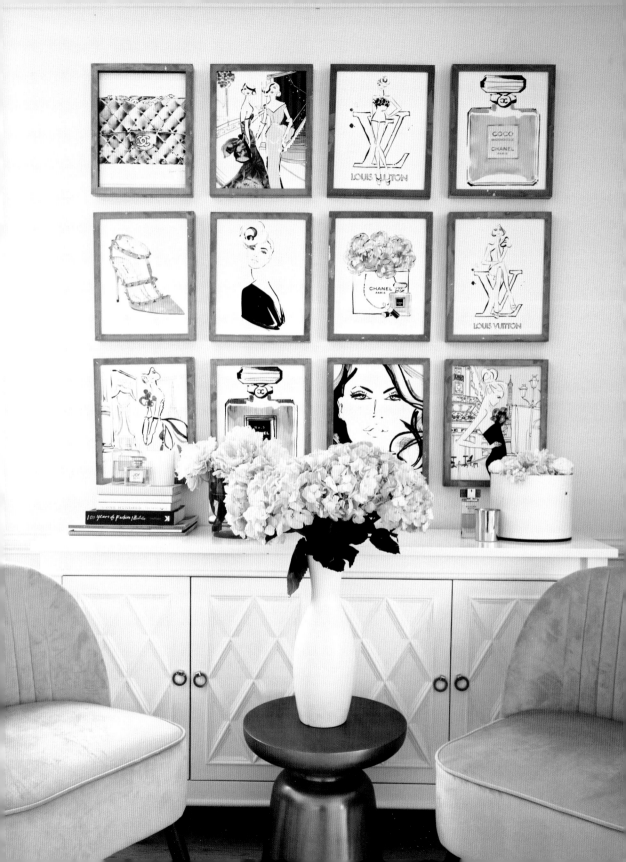

- PAPERWORK: By now it should go without saying that all stationery, bills, and general paperwork should be filed away! Or at least organized into a lovely "to-do" tray before being filed. There are few things that crush the inspiration more than a pile of bills at the start of the day.

- ARTWORK: Add instant love to your work area with a cherished piece of art, or three prints framed together in a row.

- SCENT: Perfume the office with uplifting essential oils like orange blossom, lemon, and spearmint. These aromas are wonderful for a mid-afternoon pick-me-up, as well as for encouraging general productivity and positivity.

- HARDWARE: Don't neglect the technology. Make sure to update your computer and software when needed. I put up with a computer that ran at a snail's pace until recently. Now it's updated, everything moves twice as fast as before, and I wish I had done this sooner! Updating your hardware is also a little signal to the universe (and yourself!) that your business is moving forward and worth investing in…

If you don't have a room you can claim as your own, try to nab a corner for yourself! Pop a comfy armchair in there, and a side table stacked with your favorite books, a candle, and an indoor plant. I think it's important that we have a place where we can retreat, if not to work or to read, then simply just to be and breathe for a while. It's not about the size, but the symbolism. You deserve me-time—and me-space—all to yourself sometimes!

The little (home) things

These small but joyful activities will enhance your love for where you live…

• A wintry night in, snuggled up on the couch in cozy pajamas.

• A DIY day-spa session of pampering and self-care… Do some dry body brushing, relax in a bubble bath laced with scented oil, then slather on a face mask and settle in to watch a classic movie. Bliss!

• Time to read in your favorite nook, curled up with a little cup of tea.

• A sneaky weekend afternoon nap for no reason at all!

• A Sunday afternoon spent cooking something new and delicious, with a glass of rosé at hand. Your favorite tunes playing as you chop, stir, and whisk.

• Those sips of that first coffee of the day on your sunlit balcony, or back in bed with a good book!

• An afternoon of creativity all to yourself. For me this is definitely painting, but it could be anything at all! There is almost always a sense of meditative joy in switching off and allowing your mind to focus only on where your imagination takes you.

Art and soul

Art in your home is like the sparkling diamond on top of a beautiful ring, the baubles on a Christmas tree, the lemon-buttercream icing on a sponge cake....You may not need it, but it adds a touch of joy to your home as much as to your heart. It will also bring back special memories. Maybe it's a piece that you commissioned for a heartfelt reason or momentous occasion, that you splurged on as an investment, or that you bought at a street market in Paris because you instantly fell in love with it. Or, in a case like mine, the art in your home could be pieces you have lovingly created yourself. Or maybe there's no particular reason for the art you've chosen for your home—only you know that you love it. For me, art is the ultimate just-because purchase…just because: well, joy!

There is nothing wrong with amassing art purely for investment. If you are like me and not a collector, however, the best way to buy art is not to overthink it. Choose each piece based on a feeling of instinctive delight it stirs in you, as well as whether the colors, themes, and size of the piece will work with your decor. Or, if you're decorating from scratch, you could even start with a piece of art and let it be the inspiration for the whole room.

Not all art in your home need be on a traditional canvas. Perhaps it's a sculpture, or even an amazingly conceptual pendant light. Or you might decide to display the most beautiful piece of clothing that you own on a vintage mannequin. I do this in my studio, with my wedding dress, a beautiful piece of art in itself.

Art is whatever you want it to be, but if you need some artful ideas, read on...

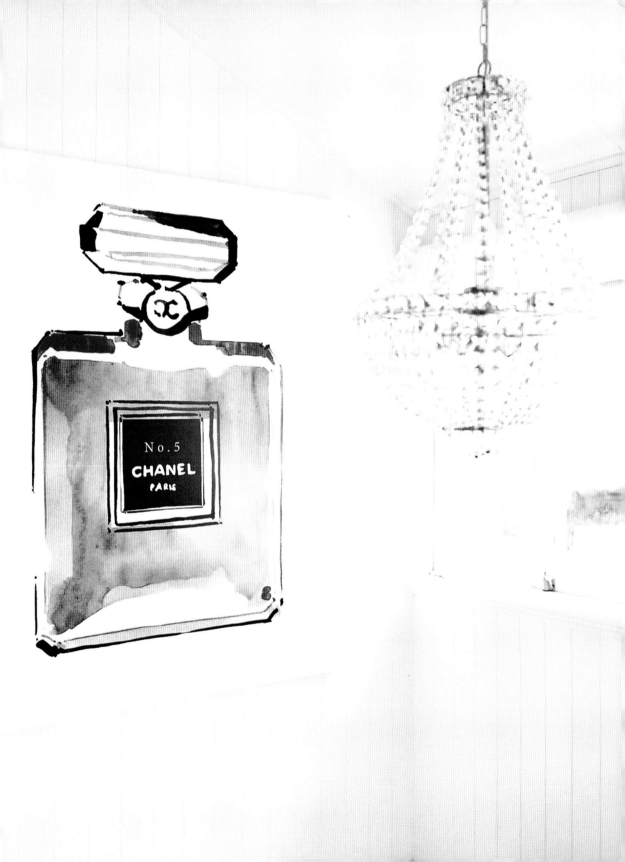

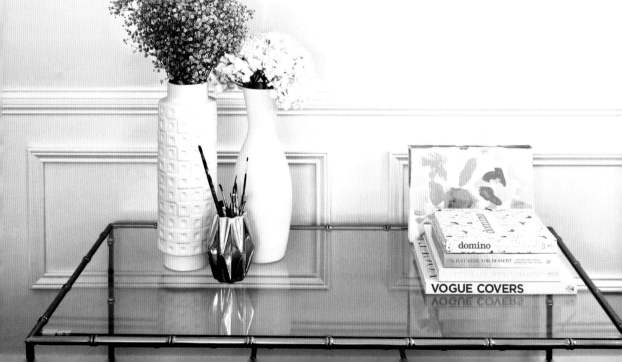

- FRAMED WATERCOLOR: A beautiful watercolor will infuse softness into any room. Try a "floating mount" in a white frame to accentuate the medium.

- LARGE CANVAS: In any big space I always favor an oversize dramatic work on canvas, a piece that feels strong enough to compete, for example, with a large couch or statement rug.

- GALLERY WALL OF ART PRINTS: Perfect for a reading nook or above a pretty buffet. Try a gallery wall of three, six, nine, or twelve pieces. If you hang them all at aligned heights in matching frames, the result can feel both ordered and playful. (Lay them all out on the floor first to check that the colors and styles work in a balanced manner.)

- ART IN VIGNETTES: Not all art pieces have to hang from the wall. Layer frames on a tall console with other beautiful things such as a vase, lamp, and perfumes. Group items in vignettes in either similar or contrasting colors and textures. Including items with special meaning will add a personal touch.

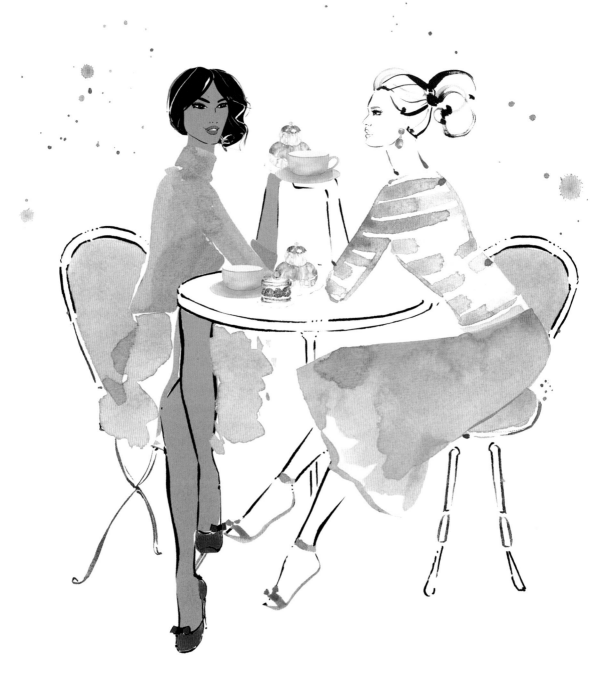

at-home happinesses

Is staying in the new going out? Well, in recent times we've had to be indoors more than we ever thought possible, that's for sure! So, how to be a happy homebody? Glamorous interior decorating schemes might be the dream, but there are many other easy ways to make your house (or apartment) feel lived in and loved. One way is to infuse the space with the energy of laughter and conversation, by organizing a variety of soirees there—I've compiled some fun suggestions over the following pages for when gatherings are once again du jour! And because you also want to feel at home when home alone, there are ideas here for making your space more of a reflection of you—for aligning your two inner worlds, in a way! Get ready to click those ruby slippers—because now, more than ever, there really is no place like home.

Host a small dinner party for old friends

A happy home is one that's lived in. Invite a few close friends around to dine. It doesn't have to be fancy—you could even order pizza and serve it on vintage porcelain plates. The point is to create a cozy space—cue candles and cushions and mood-inspiring background tunes!—in which you and your nearest and dearest can properly catch up on one another's news.

Throw a cocktail party for new friends

You know how you meet fun and interesting people and say to them, "Oh, we must go for coffee one day"? But you never get around to it because there's just not enough time and not enough days to go for coffee with all of these potential new friends...Why not schedule an intimate dinner with cocktails at your place, once in a while, where you invite some of your latest acquaintances—a blend of personalities as sparkling as the cocktails you serve! It will infuse your house—and your life, too—with wonderful new energy, because the ones who stick around well beyond a few martinis could become cherished lifelong friends.

Have the girls around for afternoon tea

Maybe it's for a bachelorette party or a baby shower . . . or perhaps it's simply a perfect excuse to dress up! In a world where women are busier than ever, both on the professional and domestic fronts, it's sometimes lovely to pretend, even if only for a few hours, that life is as slow and quaint as it once was, back when women used to catch up over tea and cake in one another's homes. So channel your inner Emma Woodhouse, and issue formal invitations to your nearest and dearest for an English-style afternoon tea at your home. It's the perfect opportunity to dust off your best china and sparkliest crystal glasses, and serve up a feast of fragrant Earl Grey, golden bubbles, and scones laden with strawberries and cream. If baking is your jam, the preparation could be as joyous as the actual afternoon— but, of course, you can always take a shortcut by detouring to your local bakery.

Host a movie night

I love and miss taking an old-fashioned trip to the movie theater, especially to some of the newer ones, with their velvet seats and sea-salt popcorn (and even wine menus!), which make a movie session seem more luxurious than ever. But with so many great films premiering on streaming channels, I also love creating an in-home viewing experience. Load up the couch with cushions, and the floor with beanbags, fill some large bowls with popcorn in various flavors, and invite your closest friends over. If you have a backyard, consider renting an outdoor movie set—this is especially atmospheric for watching old classics, such as *Casablanca* or *Rear Window*.

Make your home a haven

Inviting people over is all well and good (and feels like a
treat after a long time of not being able to, but a house
has to, above all, suit those who live in it and reflect the
personality of its owners. Splash around framed photos
of loved ones. Inject the space with your favorite color—
even if that's just, say, painting the front door pink. And
don't stress about a little mess—if it's the good kind!
Kids' toys, books on tables, pretty little trays filled with
coins and keys…

Create a personal display table

I love how boutiques showcase their most special offerings in
such artsy ways, say, with a necklace draped over a sculptural
piece of faux coral, or a bejeweled shoe within a bell jar…
Why not borrow this idea, and showcase some treasured
personal items on a console table or on a mantelpiece?
Maybe it's a collection of items you picked up during your
latest Paris holiday (a colorful Eiffel Tower, a sparkly snow
globe, a Diptyque candle…) or a beachside jaunt (a bowl
filled with colorful sea glass, a branch of driftwood …).
Maybe you feel like updating the display to welcome a new
season, or to tap into the latest Pantone color trend…Be as
creative as you wish. In addition to being a fun activity to
plan and execute, your table will make you smile all the more
every time you walk into your home.

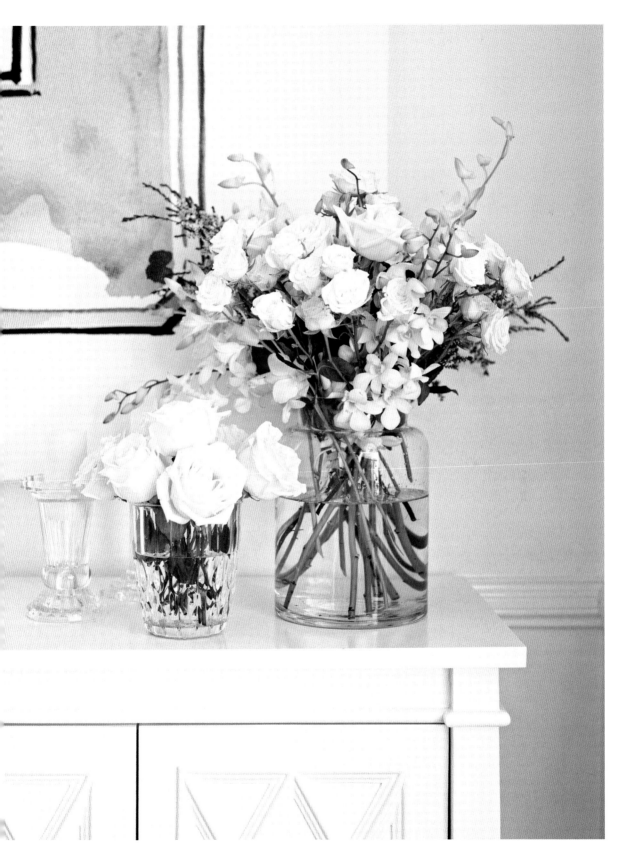

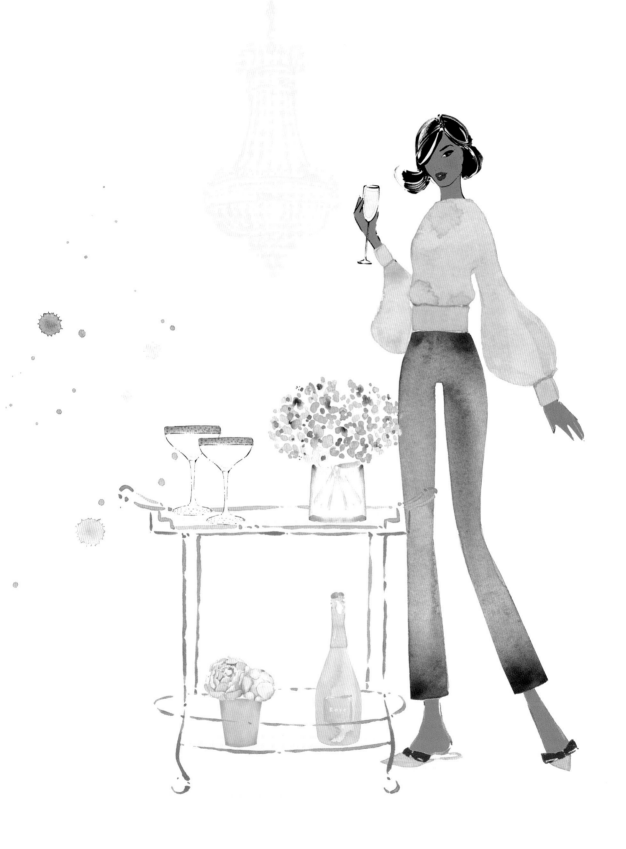

Mood-light your living space in the evening. If your lights don't have dimmers, turn them off completely and ignite a cluster of candles instead. It's a delightful way to relax the eyes and mind after a frenetic day.

Home: an artist's view

If you've ever flipped through a book or blog on artists' living spaces, you might have noticed that these homes are a little *different* from others. I think this is because artists find so much joy in the unexpected, and also challenge the "rules" when it comes to decorating. For example, you might see a glittering ornate pendant light in the bathroom, or a gold bar cart in the office…lovely elements that surprise and delight. Or perhaps it's a kitchen painted in a sunny canary yellow; artists love to use color to engage the senses, especially for a work space, or a utility area of the home that might typically be white with no special details. And white is an irresistible blank canvas to most artists; we just can't wait to splash it with color and objects that inspire!

Most artists also strive for the complete opposite of an overly curated look. We don't want to feel that we're in a showroom where all pieces of furniture have come from the same place at the same time. Artists know that trends are forever fleeting, and we see beauty in a wide array of styles. Many of us prefer to have an eclectic mix of eras represented in our furniture and furnishings, mixing the rococo with the au courant. And we also experiment with texture, both shiny and matte finishes, as well as with scale—think: a huge vase or statue in a living space.

Naturally, we grace our walls and shelves with traditional art (paintings, photos, sculptures…), but we see art in so much of the world that we could have pieces on display that most wouldn't even consider to be art: a timeless silk scarf in a frame, style books displayed on open shelves as at a bookstore, or vintage perfumes on a metallic tray.

Home should be where you rest, of course, and artists often have spaces or rooms designed to instill a sense of calm after bouts of over-stimulating work—but if you're artistically inclined you know that creativity doesn't have an off switch, and you can't help surrounding yourself with all sorts of beauty and inspiration.

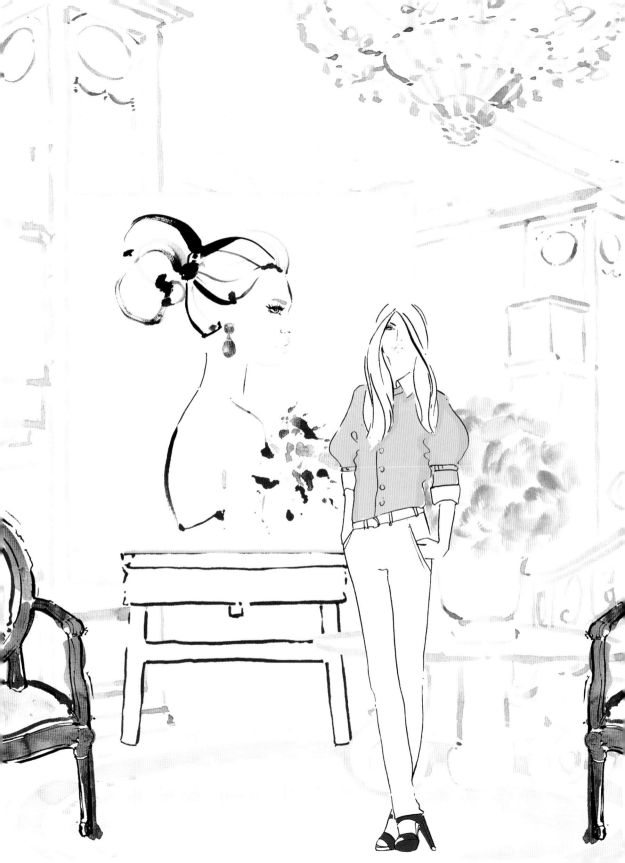

Calming and creative ideas

Channel your inner artist to create a beautiful painting for your own home. A
piece that is always lovely—and a joy to create—is a watercolor of florals. For
the most professional finish, use a large sheet of watercolor-specific paper
with a rough texture, and frame your work as a "floating image" inside a white
frame, gallery style. Alternatively, use acrylic paint in your favorite colors to
compose simple shapes—geometric forms or large circles—on an oversize
white canvas.

3

joy in
STYLE

eternal style

The great Yves Saint Laurent once quipped, "Fashion fades, style is eternal." He knew what he was talking about—this was the man who gave women tuxedos, after all! And even now that dressing has simplified, and we may not be heading into the office or to cocktails with friends, it's still important to feel good about what we wear. You may be spending more time than ever in soft and comforting casual clothes, but experimenting with dressing and finding your own sense of style will always be in fashion. And in time, there will be the excitement again of dressing up and wearing your beloved style staples. In the following pages, I've listed my favorite fashion classics, those can't-go-wrong wardrobe pieces you'll love again and again. Along with these clothing essentials, I've also detailed the accessories that offer enduring appeal—the particular handbags, shoes, and jewels that will deliver decades of happiness! And, because it's not just *what* you wear, but *how* you wear it, you'll find my top tips for carrying it all off with style, from adding the perfect finishing beauty touches to managing your wardrobe so that the ritual of dressing becomes a daily pleasure.

WARDROBE JOY

the satisfaction of a
well-edited wardrobe

Most of us get to a point where we open our closet doors one day and think, "I have too many things!" I guess it's a better problem to have than the old "I have nothing to wear!" But the thing is, we usually do have a multitude of choices—it's that most of them don't seem quite right. Perhaps we've hoarded clothes from our past experimental years way beyond their expiration point, or maybe we got a bit too excited with trend-based fashion, buying into fads that barely lasted a couple of weeks.

Let me add a disclaimer: Parisian women don't tend to have this problem. It was during my years in Paris, when I had a closet that was pretty much the size of a shoebox, that I came to reassess my wardrobe philosophy as much as my personal style.

I had to limit my wardrobe to my favorite things—and I found that I stuck with the pieces that made me feel my best when I wore them. These tended to be the items I had invested in, and that were classic enough in style that I could put them on again and again. My Paris years helped me hone the art of buying less but better. And while I am not completely immune to a bargain, I also learned to avoid fast fashion. This led to an unexpected sense of calm, because it was a choice that not only enhanced my personal style but also benefited the environment.

What to display, what to store...

I love a clothes rack—it adds a touch of movie star glamour to a room! This is especially true if you use it to display your most cherished items of clothing. Being able to see my favorite pieces every day not only brings a smile to my face, it also reminds me to wear them, rather than wait for a rare special occasion!

I tend to keep the light pastel tones together, and the shades of white in a separate grouping. Try displaying pieces that bring out the most joy for you...You might have a collection of little black dresses that you'd love to show off.

I stick to classic pieces as the basis of my wardrobe, then add various items that strike my fancy, and that I know I will adore for years.

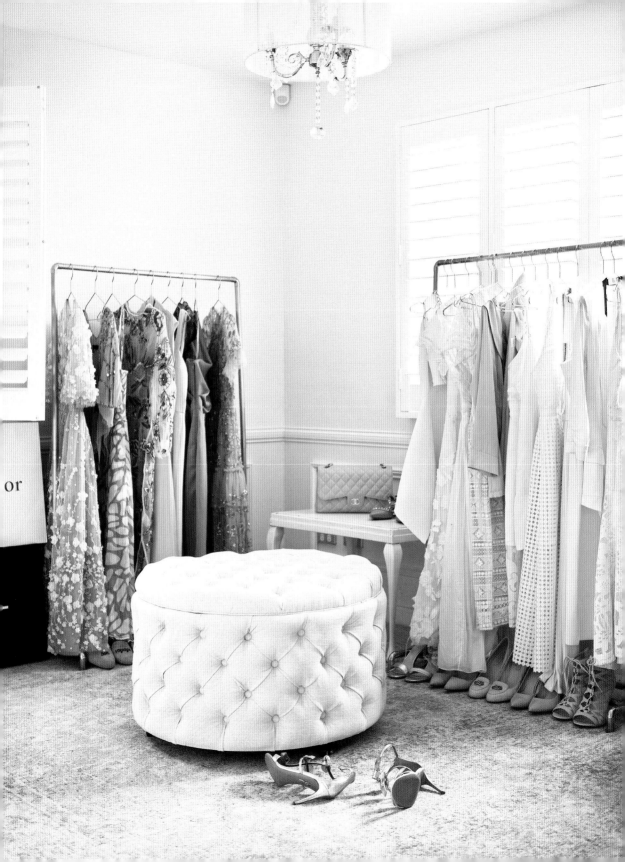

classic clothing you'll covet forever

Every creative industry has its timeless favorites. Literature has *Little Women* and *Anna Karenina*. Music: Mozart and the Beatles. Architecture: fluted columns and graceful domes. Movies: *Vertigo* and *Dirty Dancing*. Bear with me here... Because so too does fashion! There are simply some creations that are so universally admired and eminently admirable that they immediately shoot to Hall of Fame status, never to fall out of favor—nor fashion. Speaking of which, you don't have to own an array of expensive designer pieces, just a well-edited selection of wardrobe staples that you collect, care for, and keep with thought and pride. The following are the essentials I've come to love in my own wardrobe. Feel free to use this list as inspiration for creating your own perfect capsule collection of clothing...

Breton stripes

We must also thank Coco Chanel for another much-loved fashion look: the blue-and-white-striped boat-neck top. In 1917, while on vacation, Chanel was inspired by the "marinières" worn by Breton fishermen. The rest is fashion history! These days, little looks chicer (in a simple, understudied way) than such a top worn with jeans. You can also find marinières with colorful stripes, if you want to add some brightness to your day.

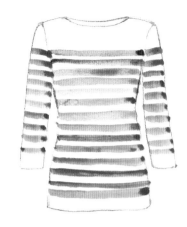

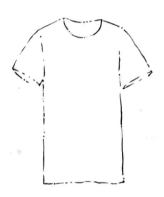

White t-shirt

The humble white T-shirt will always be the ultimate casual piece that never dates. As long as it stays white, that is! When your tees start to look a little yellow and, well, stale, buy a new batch to keep the look fresh. Wear with anything and everything, such as those much-loved dark denims, a pretty floral day skirt, or even a fitted pencil skirt for a high-low spin on evening wear.

Tailored blazer

I've long believed that the unofficial uniform of Parisiennes is a black blazer paired with sleek, dark denim jeans. And why not? It's such a simple, universally flattering combination. A black blazer also looks amazing with black leather pants for a sexy take on evening dressing. Go for a tuxedo style (think "le smoking"—made iconic by Yves Saint Laurent in 1966) if you want to make a strong statement, or choose a suitlike cut if you're more of a minimalist…No matter the style, the most flattering length tends to fall to right below the hips.

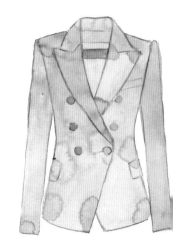

Dark denim jeans

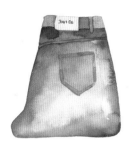

Matched to the aforementioned striped top or blazer, or with even the simplest T-shirt (think Jane Birkin), jeans are a wardrobe essential. They flatter a wide range of shapes in a dark shade of denim, when the leg is cut straight, and when detailing is minimal.

Beige trench coat

I find no coat to be more perfect for in-between weather than a beige trench. The design traces its origins back to the English military of the nineteenth century, but nowadays it's a modern urban essential. Even if you can't stretch your budget to cover an iconic Burberry, there are always many affordable versions of the beloved beige trench coat to be found. And if you find beige to be a somewhat ho-hum color, you can always look for a trench in a cheerier shade, such as a rich green or burgundy.

Black cigarette pants

Slimmer cut than straight leg, but not as tight as skinny leg, the cigarette cut is universally flattering. Dress these pants up with a fitted blazer and heels, or wear during the day with flats and fluffy cashmere. An all-around hardworking wardrobe piece!

White shirt

Meet the big sister of the white tee . . . A crisp white shirt is refined and professional, especially worn with pearls and a jacket. But here's what you need to know: it's also one of the most versatile pieces in your wardrobe, because it works well beyond the office. Wear on the weekend, knotted at the waist, and with a statement maxi skirt, or even over a swimsuit on vacation . . . The white shirt's possibilities are endless.

Little black dress

Universally considered the key staple of any woman's wardrobe, the little black dress came to life in the 1920s, when both Coco Chanel and Jean Patou designed dresses in a shorter length and in the practical shade of *noir*. The LBD was a revelation at the time, and these days we couldn't imagine life without one. This clever frock can be fancied up with heels and jewelry, or dressed down with flat sandals and a canvas tote, making it a most useful travel item. And while black has a reputation for being a somber, serious sort of color, keep in mind that an LBD doesn't have to be; look for one in a textured fabric or with trims such as frills for extra fun factor, or set it off with colorful accessories for an instantly enlivening effect.

Peacoat or wrap coat

A well-fitted coat is instant pulled-together polish, but it need not look too stiff and buttoned up. I love the short sailor-inspired style known as a peacoat for the weekend—it has an effortlessness to it. And for work appointments or evening events, a wrap coat manages to look both luxurious and professional.

Pencil skirt

Striking the perfect balance between prim and sexy, this skirt can go anywhere! Look for a knee-length style in flattering black and in go-with-everything beige—you'll find they work beautifully with most every top you own. Cinch your waist in with a belt to enhance the air of old-school glam.

Leather jacket

A timeless classic best paired with all black or contrasting softer tones—this is the perfect midseason jacket with just enough edge sprinkled in! Wear it over jeans, black pants, a maxi skirt, even floral dresses.

Tweed jacket

This is such a sweet addition to a wardrobe. You could choose a boxy Chanel-inspired tweed jacket or maybe a more English-style hunting jacket (minus the hunting!)—either way you've got yourself a classic that will keep you warm (and looking stylish) for many winters to come.

A boyfriend is all well and lovely…
but every girl most certainly needs
a *joy*friend. She's the one who's
always there to give you a morale boost,
to meet you for happy hour at the drop
of a hat, to have you over and hold your
hand when your world seems to be
crumbling down around you…
Hold her close to your heart, and
make sure you're always there for her,
too. Little is more crucial for a happy
life than soul-affirming friendship.

Six ways to wear a little black dress

Take one simple, slinky, sleeveless black dress, and you've got the first step to a look for any and every occasion…Joy!

1. A black blouse with billowing sleeves, worn unexpectedly beneath your LBD, makes for a more sculptural silhouette. *Très élégante*!

2. Slip your LBD over sleek black leggings—and soaring stilettos—both to extend your frame and to add some cutting-edge allure.

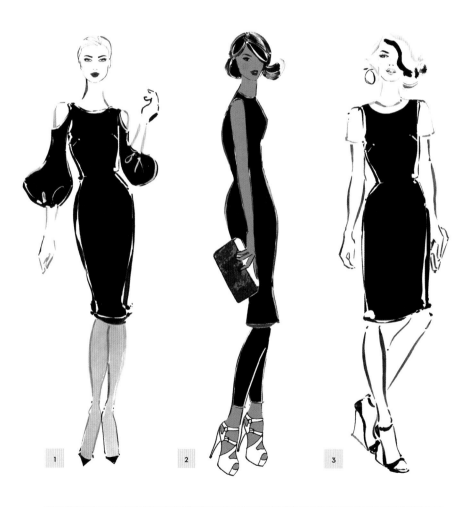

3. Wear your dress over a neat white T-shirt for an *à la parisienne* weekend look. This pairs perfectly with wedges.

4. Match your LBD to a crisp white blazer for a monochrome effect that is seriously glamorous.

5. Channel Chanel and clasp a floral brooch to your neckline. That's it. The essence of simplicity.

6. For an evening option, simply layer your dress over tights and pile on some jewels.

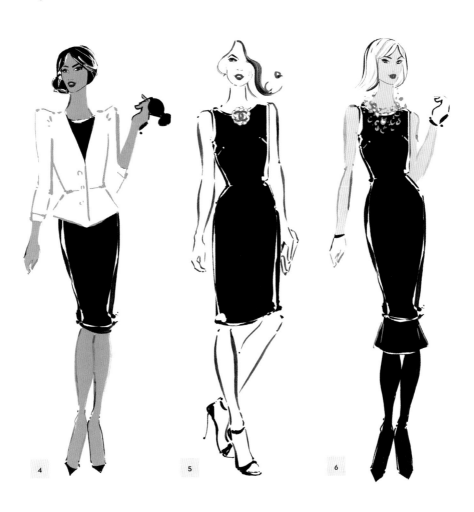

4 5 6

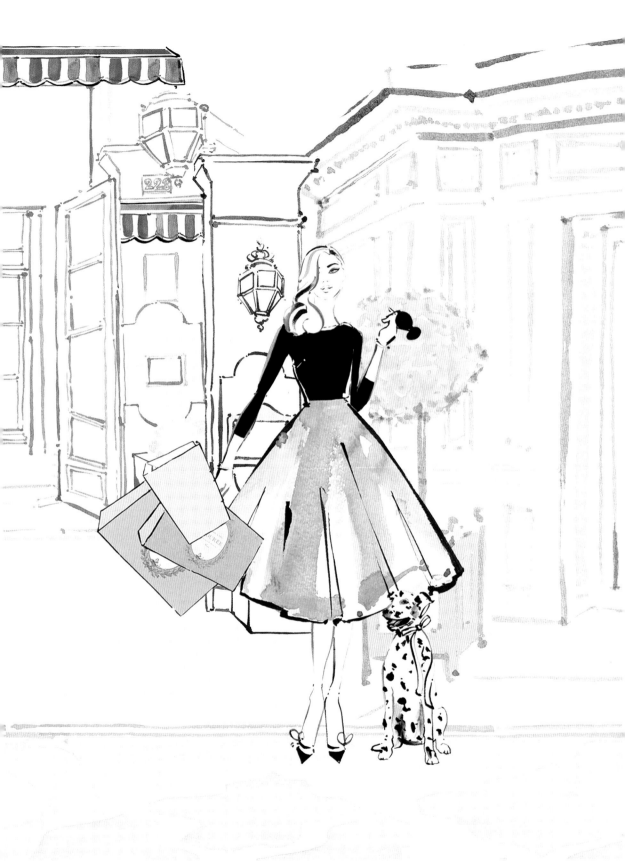

Tips for keeping your closet tidy and organized

Anyone who has ever visited my home or office would know that I am most definitely not a minimalist! Still, I do appreciate the feeling of owning less. I swear that lightening your wardrobe has a decluttering effect on the mind, too! I used to find it so stressful sorting through a crowded wardrobe every morning, not being able to find a certain piece, and knowing the clock was ticking. If you can relate to that, here are some ways to keep your wardrobe tidy and organized...

- Do one major clean out (à la Marie Kondo's *The Life-Changing Magic of Tidying Up*) every six months, or at least once per year. This is not a ten-minute piece-through of your closet; this is hours of trying on everything and making the charity pile as high as possible. Thank the clothes you are liberating from your wardrobe (my favorite tip from Kondo!) and enjoy the extra space you have that lets you see your remaining clothes.

- When going though clothes, ask yourself if each item represents the person you are right now, as well as the one you want to be as you move forward. You might own several pieces that were perfectly right for you a few years ago, but don't express who you are now, or what you want to embody in the future. Let those items go.

- Commit to buying fewer clothes: less but better. Enjoy the sensation of wearing a truly beautiful dress many times over. This feeling is so much more meaningful than slipping on a new fast-fashion frock for every event.

- Create a space in your wardrobe in which you can place items that require repair or adjustment, and deal with these items on a regular basis.

- Make a point to display the items that you love from your wardrobe—I bought rose gold hangers and clothes racks for this exact reason! You could set up a display like this in a corner of your bedroom or even your office. Think of it as fashion art!

- My day-to-day T-shirts and jeans are organized neatly in my closet. The same goes for my everyday shoes. But I showcase my fancy shoes where I can see them. Even if you can't wear your jeweled shoes every day, displaying them means you can still enjoy them!

Wear rose-tinted glasses...
literally, as well as figuratively!
There's a reason pink-hued
sunglasses are so popular:
looking at the world through
a rosy glow makes everything
seem that much prettier!

Fashion: an artist's view

There are so many fashion "rules" out there about what to buy or wear, but for me, what's most important is that the outfit feels good on my body. Fabric is a key element. I love the luxuriousness of soft wool or cashmere in winter; in summer, I want the sensation of glistening silk or paper-thin cotton against my skin.

Of course, color also plays a vital part in what I choose to wear each day. I feel calm and collected in tones of white or beige, optimistic and cheerful in bright shades like coral or aqua, feminine and creative in pastels, and powerful and efficient when I wear black. Picking out my outfit the evening before puts me in a more relaxed state for the process, and it makes the morning less hectic.

I always try to be creative with fashion—and I don't think you need to be an artist to carry this off! Just experiment until a new combination is right—you'll instinctively know when that is. And often you'll by surprised at what works; say, an evening dress with sneakers for daytime, or a floral skirt with a leather jacket. And try to reimagine other pieces; perhaps you can belt a long skirt into the form of a strapless dress, or maybe a wrap dress will work brilliantly as a summer "jacket." You might find you have many more outfit options than you realized! Draw inspiration from the way your favorite female fashion designers and artists dress themselves, then give their intriguing combinations your own interpretation with what you have. Being creative with fashion is not only fun, it's also a great way to expand your wardrobe at no cost.

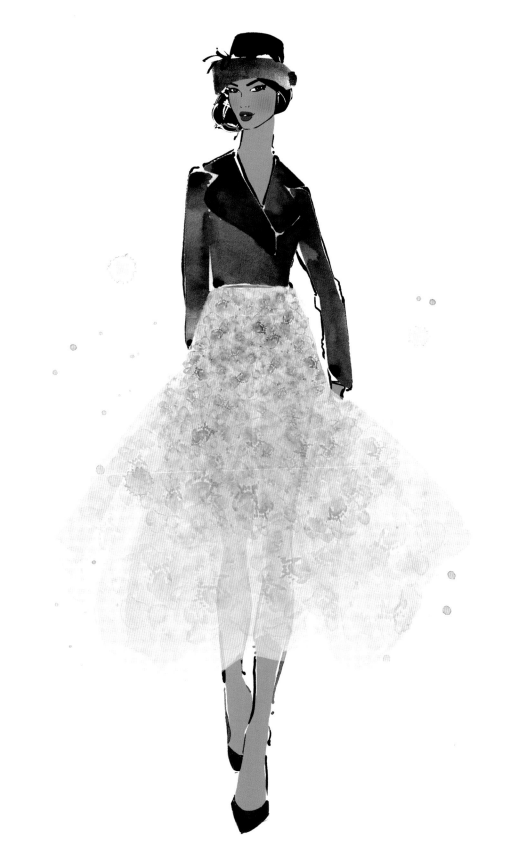

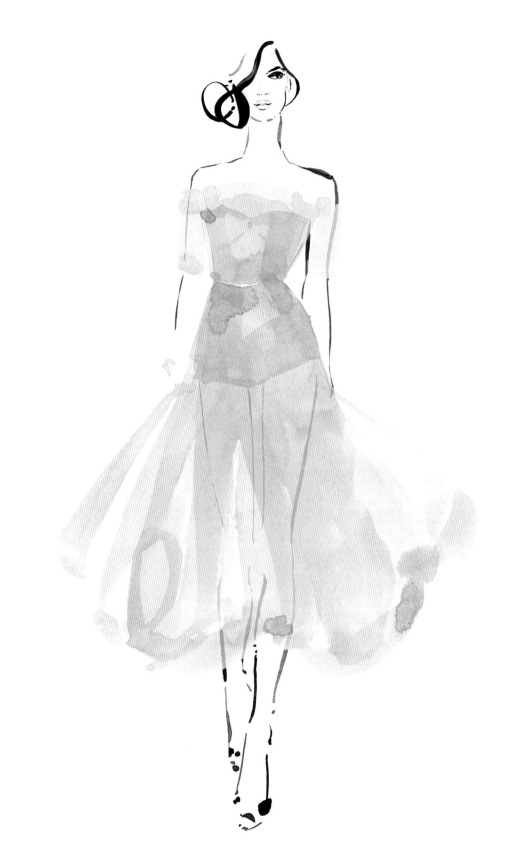

Calming and creative ideas

Set aside an afternoon to try on pieces that you haven't worn for months, even years. Remind yourself what drew you to each piece in the first place and how you might be able to restyle any items that no longer fit or feel right. With a tailor's help, a bright wrap dress could, for example, be shortened into a light summer jacket to wear over a white tank top and pants. Alternatively, help your partner with a wardrobe clean out—because a too-small white shirt on your partner might be the perfect slouchy cut on you!

HANDBAG JOY

the beauty of owning
one "forever bag"

In the spirit of buying more quality, less quantity, there is no style essential that better lives up to the "cost per wear"* theory than the handbag you carry around with you most of the year. This is the one item in your wardrobe that, more than any other, should make you smile.

It doesn't have to be the most expensive bag around, or the one that all of the fashion blogs recommend—what's important is that you adore it. And for extra justification, it should be practical, able to fit everything you need for your day…but still light enough that it doesn't literally weigh you down. In a way, your perfect bag becomes an extension of yourself. Even in times when we are out and about a lot less, one forever bag is still necessary to hold both our essentials and our treasures.

Several years ago I spotted a vintage Chanel 2.55 handbag, black with gold hardware, at a consignment store. It was the perfect size—large enough but lightweight. And it was much loved, scuffed from twenty-six years of ownership in its previous life in Hong Kong. Still, it was expensive. So I went home to think it over…And after some mental mathematics, I realized that the

"cost per wear" would end up being negligible, because I knew I would love and carry it for decades. This lovely, albeit somewhat worn, bag has been my personal favorite every day since. (It surely helped that the bag was vintage and already a little marked; I could then happily tote it around every day without stressing too much about tiny scratches. It already had quite a few!)

What's your "forever bag"?

* Here's a reminder about the "cost per wear" theory (a.k.a. the most fun kind of mathematics!): Take the price of an item you're considering buying. Reflect on how many times you'll likely wear or use said item in your lifetime. Divide the price by that number. Now, ask yourself: would I pay seventy cents per day for the joy of carrying that bag? (Or ten cents to sip from that porcelain cup, or forty cents to spritz on that niche fragrance, and so on . . .). If the answer is yes, you can justify the splurge!

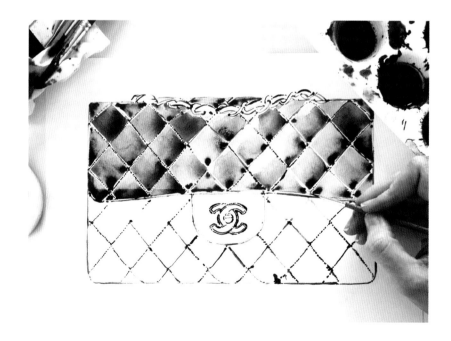

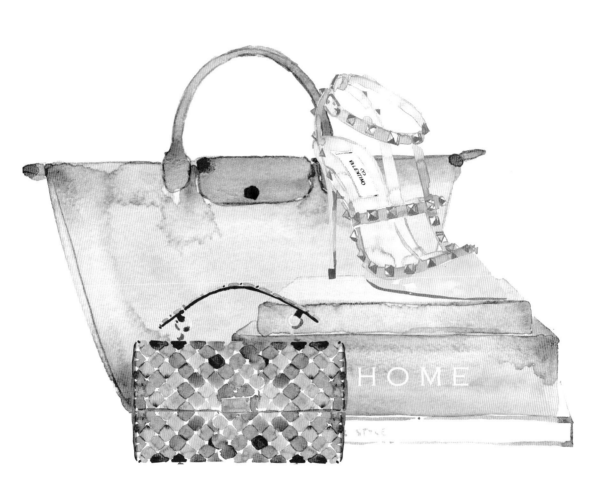

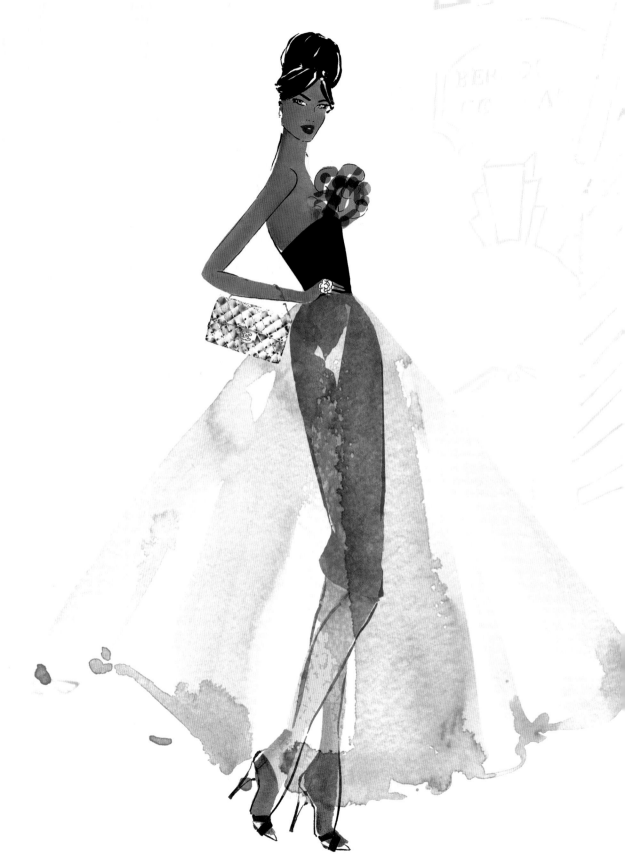

handbags to have and to hold

While the desire to covet an endless array of handbags has certainly lessened in recent times, there is even more reason now to want better but less when it comes to handbags.

Buying a bag can still be an enjoyable style decision. And it's ideally a long-term commitment. Because, for one thing, a beautifully designed and structured handbag can be a work of art. And good art purchased with careful consideration is always a wise investment! A handbag is an accessory that adds zing and swing to your look. But a handbag must also serve a more serious purpose: we carry our lives around in it! Whether it's a pair of earrings for evening, a mask and hand sanitizer, or other essentials like keys, money or credit cards, and tissues, we rely on handbags to get us through any situation the day (or evening) might throw at us…As paradoxical as it is, a handbag, for all its extra weight, can be joyfully liberating! You might focus on one signature handbag to rely on, one that adds a spring to your step even if it's just to pick up groceries and flowers. Read on for some suggestions.

The everyday classic

This is the bag you rely on to make you look pulled together instantly— even when you are feeling anything but. It holds your life—well, your phone, keys, lipstick, and anything else you need on you on a daily basis. Neutral tones such as black, beige, or gray tend to be the best option for your classic everyday bag, but if you are one of those women who can carry off a shocking-pink handbag as your signature accessory, brava!

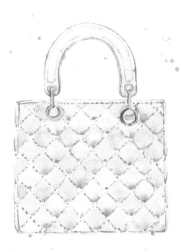

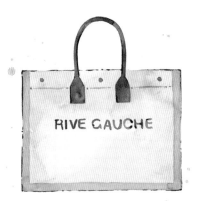

The canvas shopper

This is probably the least sexy bag of them all, but one of the most practical. (Think: the sneaker of the bag world!) It's genius for carrying the dinner ingredients you pick up on the way home, a clutch of books, your laptop, even a picnic . . . there are just so many uses. I like to keep mine in my car for any unexpected purchases while out and about. A neutral tone works well in almost any situation.

The evening clutch

For me, this frivolous little bag doubles as bling, and it's just the thing to offset a beautiful dress or a tuxedo jacket. My favorite is a clutch that has a secret strap, for when I need to have my hands free. Just be realistic about how small you can go with an evening bag. (I wish I could head out for a night with only a credit card but, unfortunately, I know my limits!)

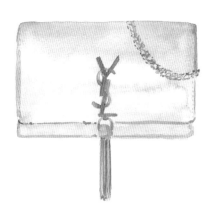

The travel tote

Like most women, I tend to come home from a trip—even of the brief work variety—with much more than when I started out. There's something too irresistible about shopping in a new city or country! That's why I always pack a superlight travel tote in my luggage, to double as a carry-on when I'm en route home. There are many featherweight travel totes around. You can be terribly fancy with one from a luxury brand, but my personal favorite is the (much less expensive and lighter) version from Longchamp, known as Le Pliage. It works perfectly whether folded to almost nothing in your suitcase or sitting snugly by your feet, and it also makes an ideal overnight bag.

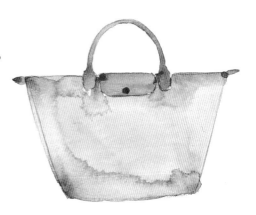

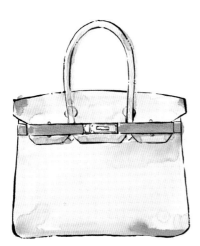

The dream bag

I love that dream couture bags like an Hermès Birkin or Kelly exist, and the stories of their craftsmanship inspire awe. I also appreciate them as beautiful objects and works of art, which is why I adore sketching and painting them. You might be someone who is determined to work hard and one day treat yourself to a Birkin or a Kelly. Or you might be like me, content simply to dream...

Handbags: an artist's view

As I mentioned, I like to consider a handbag as wearable art. An unexpected or unique shade or shape can add an element of eclectic style to an otherwise simple ensemble. Think: a fuchsia satin evening bag paired with a little black dress, or a structured leather tote with jeans and a simple tee. And whether it's a secondhand piece, an on-trend find, or a designer splurge, a handbag is an opportunity for stylish detailing, be that a spray of sequins or a scatter of studs or a vibrant floral print. A handbag doesn't just have to be something you hold, but something you also hold dear.

I admittedly have a weakness for beautiful things, but I fall even harder if there's a lovely story to a piece, such as the vintage black Chanel in my own collection. Bags are often items we buy to reward ourselves for, say, a promotion. And the most special ones in our wardrobes have often accompanied us out on memorable evenings. So handbags are "Proust's madeleines" in a way: they take you right back to a particular night out, or to a happy moment in life.

Don't be afraid to experiment with bags as you do with your clothes. Add a brooch, for example (or a few), to jazz up a simple clutch, or hang some charms off a handbag chain. I also love to twirl on a scarf, a tip I picked up from Parisiennes. Believe it or not, on my last day living in Paris, at my local market, I found what would become my handbag scarf. I happened across a charming older lady selling a collection of vintage printed *foulards* and zoned in on a particular one with spirited tones of aqua, sky blue, and gold. This lovely lady told me that her partner had gifted it to her soon after they met (forty years earlier!) and that she had worn it on her first day as a seamstress for a leading Parisian fashion house. There were so many memories wrapped up in this one piece of fabric I just had to buy it! And now, every time I wrap this gorgeous scarf around the handle of my favorite handbag, I feel like its history is living on with me...

SHOE JOY

for the love (and support) of shoes

I've rarely met a woman who doesn't have a soft spot for beautiful shoes—whether she's admiring them, wearing them, or shopping for them. I believe we're justified in devoting good money to things that physically support us through life. A mattress and pillow, for instance. A bra, too. And, of course, shoes! We're typically on our feet for so much of the day, after all, and a lovely pair of shoes alters the way we walk, and in turn the way we feel. The right pair of shoes can make you feel incredibly powerful (just as a painful pair can ruin your day and night).

And there's something both soothing and uplifting about being at home in your favorite pair of cushioned flats, which can be both comfortable and chic for a day of work; or wearing shearling-lined boots for winter days in; or soft and fluffy slippers in the evening as your workday melts away. Spending much more time at home has also made the occasions that do call for a sparkly pair of heels even more special.

falling head
over heels

My general rule of buy-less-but-better also extends to shoes. Buy the highest quality pair you can afford, wear them whenever you like, have them re-heeled and resoled regularly, and replace them when they've gone as far in life as they can go. It's a much more cost-effective strategy than building a wardrobe where you end up with many similar pairs in any category of shoes.

Some years ago, during a work trip in Spain, I happened to have one magical day off to myself and was thrilled to meet up with a girlfriend I had missed for many years. We wandered through cobblestone streets, window-shopping and stopping for pastries along the way, when I came across a pair of red heels. Adorned with delicate gold bees, the heels caught my eye in the window as the bees glimmered in the sun. Add tiny red shoestring straps and my favorite heel height and I was in love.

It was not the right time for me to splurge on shoes and they weren't available in my size (a sign!). So I walked away from the store trying to forget about those little gold bees! Nine months later, on a weekend trip to Sydney, I was walking past the window of a little boutique when I noticed the store had one single pair of little red shoes on display that looked just like "mine." I picked them up to check that they really were "my" red shoes; yes! And as luck would have it, this one and only pair was in my exact size and on sale. The shop assistant mentioned that an overseas customer from Europe had recently returned them. The shoe stars had most definitely aligned…

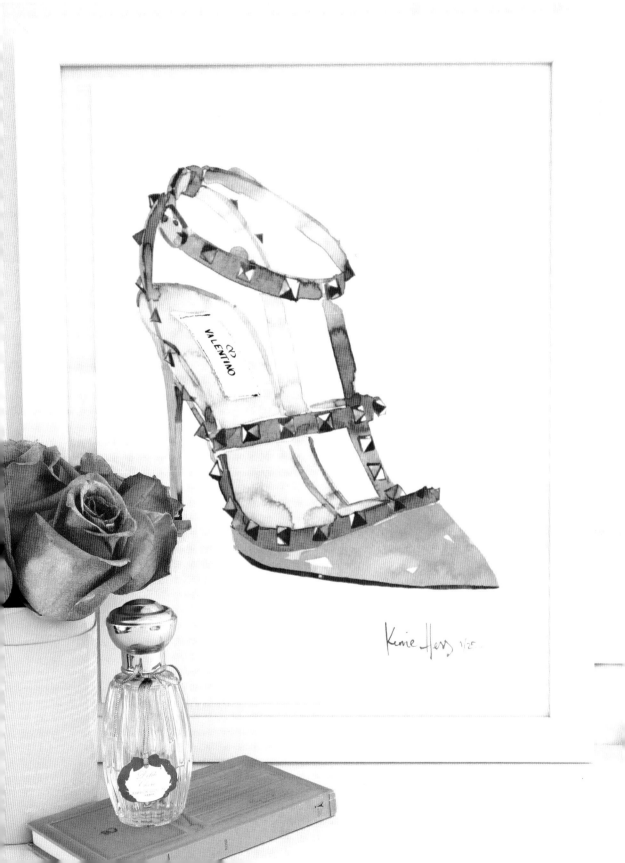

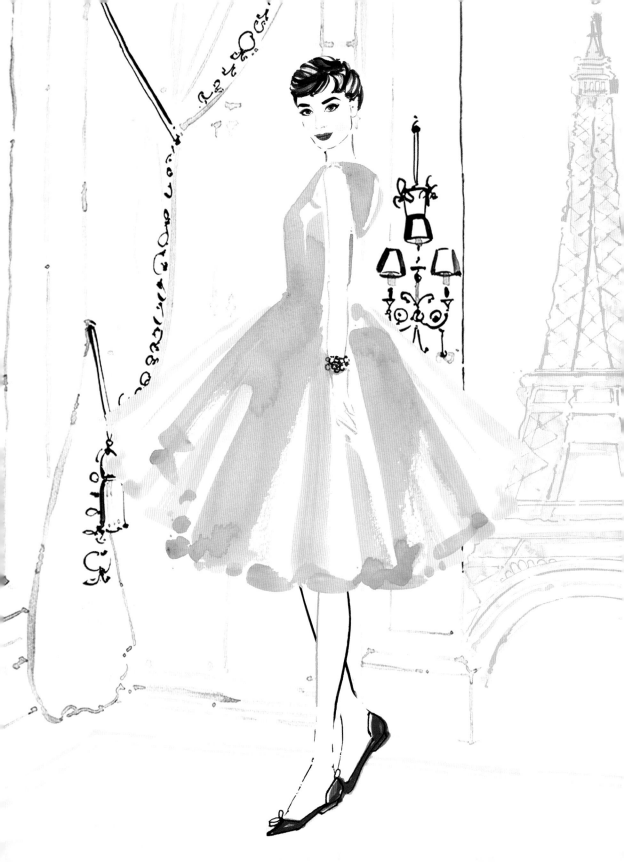

stylish steps to your perfect shoe wardrobe

Shoes are surely the most symbolic of all wardrobe items. They take us places! They help us put our best foot forward! They can literally lift us up! But I think one of the reasons we women are so smitten with shoes is that they suit everyone, no matter our shape or height. Every woman can, in theory, wear any style of shoe, from a flat to a sky-high heel, and everything in between. Your shoe collection can be as mini or as maxi as you wish. Mine is somewhere in between! For inspiration, my go-tos are on the following pages…

Ballet flats

Ever since I fell in love with Audrey Hepburn in *Roman Holiday*, my favorite day-to-day shoe has been the ballet slipper. This multipurpose flat shoe works as well with jeans as it does with pretty much any style of skirt. I personally love a soft slim-line style that shows a little hint of "toe cleavage." The ultimate classic ballet flat, of course, is Chanel's two-tone beige-and-black design. But you don't have to limit this shoe to neutral shades—it also looks gorgeous in pastel hues and bright colors like magenta.

Sneakers

I'm pretty sure that every Parisienne owns a pair of lightweight sneakers. You see these shoes flitting all over the City of Light, usually paired with the beloved outfit of jeans and a striped top, but also with floral dresses in summer. I adore a classic canvas Converse, or a pair of sneakers in white leather, which is bright and breezy, while also easy to keep clean.

Velvet loafers

Once a very masculine shoe (just add a pipe), velvet loafers have recently become a must-add to my shoe wardrobe. Both laidback and luxurious, they exude style and confidence. I like to play up the androgynous appeal by pairing them with jeans or other pants. Or look for a sweetly embroidered design to give a feminine kick to any outfit.

Pointed flats

Pure comfort and style wrapped up in one little hardworking shoe style. No other option can take you from a work meeting to a school pickup or a trip to the grocery store more easily than a pointed flat. Classic black is always work appropriate, or try a bright hue for a pop of color with a neutral outfit.

Slippers

Whether you choose a pair that are tailored and video-conference-friendly, or the super soft and luxurious style to slip into for a glass of wine and a romantic comedy, a pair or two of slippers will set your mood to relaxed and content at home.

Strappy flat sandals

Think of the iconic Les Tropeziennes—the famous sandals made in Saint-Tropez since 1927. Just the thing for holidays and summertime, strappy sandals look especially fabulous in a metallic, like rose gold, to accentuate a bronzed leg. I love these sandals for serious vacation vibes, matched with a floaty dress or maxi skirt.

Flat boots

Whether riding boots or ankle boots, these are a great winter staple. Try wearing them with dark denim and a blazer for an everyday polished look. They're as chic as they are practical in black or chocolate brown.

Kitten heels

How could you not adore shoes with such a name?
Also, they are high enough to appear glamorous for
evening, while supporting the natural arch of the foot
and keeping pressure off the toes. I find the strappy
version most comfortable but do love the look of the
close-toed slingback variety. For me both are chic and
ladylike without the pain that comes with so many
super-high heels. A win-win!

Pumps

The pump is the most classic shoe of them all, because it works for
everyone. It's demure enough for the office, yet curvaceous enough
for after dark. The pump is particularly flattering in a shade near or
just a hint darker than your skin tone and with a pointed toe (for that
visual leg-lengthening effect), while a black pump in shiny patent
leather looks great with almost any outfit. For those who can't easily
wear the higher version (like myself!), a mid-height heel works well.

Statement heels

You might not wear these everyday…since they're the shoes
in your wardrobe that are the highest you can go without
grimacing! But they put a wiggle in your walk, and make you
feel like the sexiest version of yourself. Once again, heels in
your skin tone will visually stretch out those legs of yours, but
serious statement heels love to show off color and sparkle.
Think of these as jewelry for your feet, in any color, style, or
finish you like!

Take your shoes off every time
you step over your threshold.
This is a nifty signal to your body
that it's allowed to soften into
relaxation mode. Find a lovely
vintage-style shoe rack for the hallway,
and invite all your guests to leave their
shoes, too. When you're barefoot,
or just in soft slippers, you're both
literally and figuratively more
grounded, and you'll feel a lovely
sense of balance.

Shoes: an artist's view

As with clothing, I buy shoes largely based on how they make me feel. Is my arch supported just right so that it's as though I'm drifting on clouds when I walk? Do the tips protect my toes without pinching them (or chipping my polish!)? Does the buttery-soft leather—or even a good-quality vegan fabric—breathe, so that my feet are soft at day's end, not swollen and sweaty?

I adore bow-tied ballet flats. They're a pretty way to get easily from A to B. But I go weak at the knees for a beautifully crafted pair of (not too high) statement heels. It's more than the shimmer of the silk or the sparkle of the beads that these shoes evoke. It's also that I appreciate the artisanal aspect of designer shoes, the meticulous and loving care that has been taken in fashioning the just-so heel or the gleaming satin or the flower-shaped sequins. Which is why I display them in a row at the bottom of each clothes rack in my home, like little works of art!

I also love a shoe with a story—is it a classic style that the brand has designed for decades, or does it step back in time, say with a 1940s-style wedge sole or curvaceous 1950s-esque heel that would have made Marilyn Monroe swoon?

Color is also a crucial factor for me when it comes to heels. I swear you have more energy when wearing red shoes than beige! Different tones create a different mood. Sometimes you need to be grounded and classic in monochrome; other days call for more pep in your step!

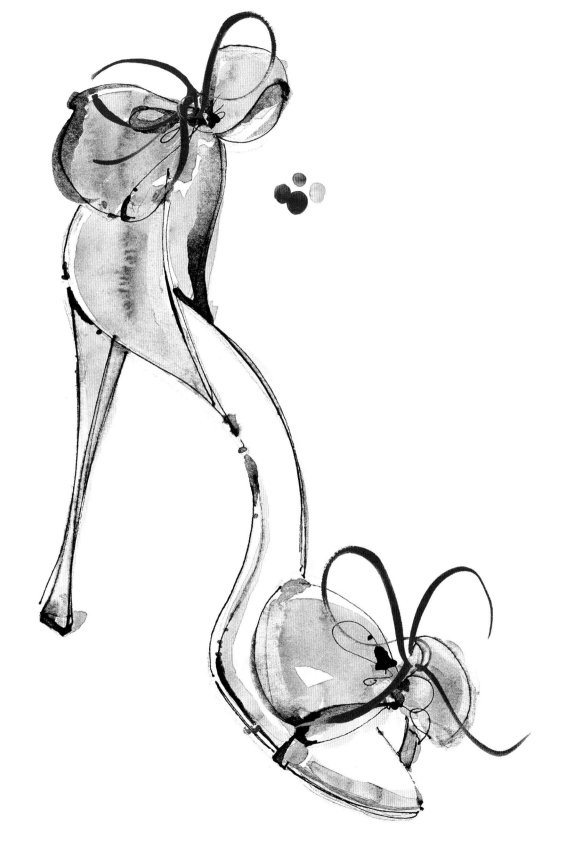

JEWELRY JOY

the pleasure of pretty gems and precious jewels

A small box of jewels with sentimental meaning can be so much more special than an entire wardrobe full of clothes. While our jewels may not always be for show, there is so much pleasure to be had in jewelry simply for yourself. That vintage pendant passed down from your grandmother, that cocktail ring you bought yourself when you landed the promotion of your dreams, the engagement ring from your love... They all have glittering memories and emotions embedded within. Try wearing them sometimes just because, not only for special outings. And as with clothing, a capsule collection of sparklers is better when small and meaningful, kept together in a beautiful box or glass display case—it sure beats a million mismatched items (that don't mean that much to you) scattered all over your home.

To give your jewelry collection extra-special treatment, bring all of your pieces together, single out those that make you smile or sigh, and then sort them by category. Make a point to wear these pieces not only on celebratory

occasions, but also whenever you feel your day could do with a little more dazzle. Cocktail rings on a Monday? If it inspires you to work more brilliantly, why not?!

Years ago, after wrapping up a successful (but incredibly time-consuming) solo exhibition of artworks, I bought myself a white-gold and morganite ring to signify having labored tirelessly for more than six months to get through the project. (And as an artist, exposing yourself by displaying your original art takes a certain amount of courage!) Over that same time I had set up a new home for myself and my son, just the two of us. So it was a period of great change. And while the ring itself is incredibly beautiful, I bought it because it symbolized strength for me, and I wanted to have something to remind me that I could accomplish anything I set my mind to. To this day, when I have a mountain of work in front of me, I wear this ring to remind myself what is possible. There is so much joy in this kind of a talisman! Similar to the way a pendant necklace given to you by your true love can make you feel cherished every time you wear it, so too can a piece that signifies achievement remind you of your potential.

The moral of the story: wear the jewels that make you shine in the best kind of way!

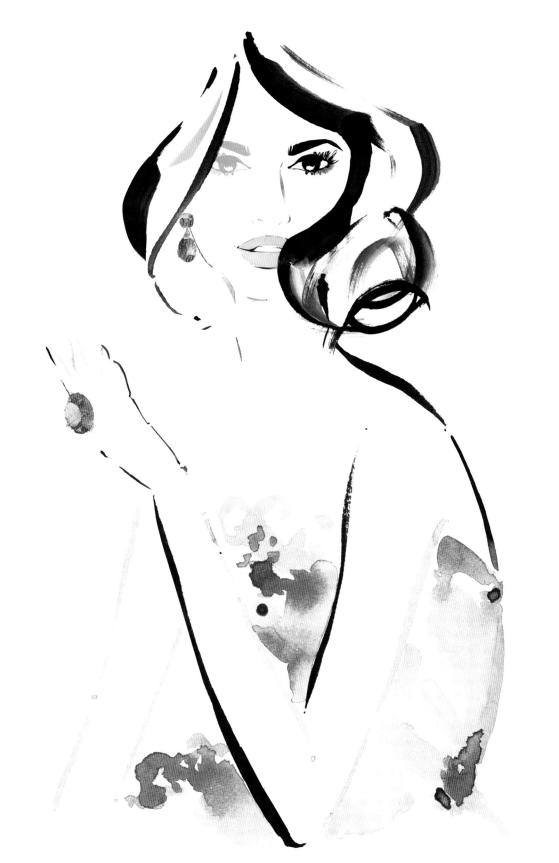

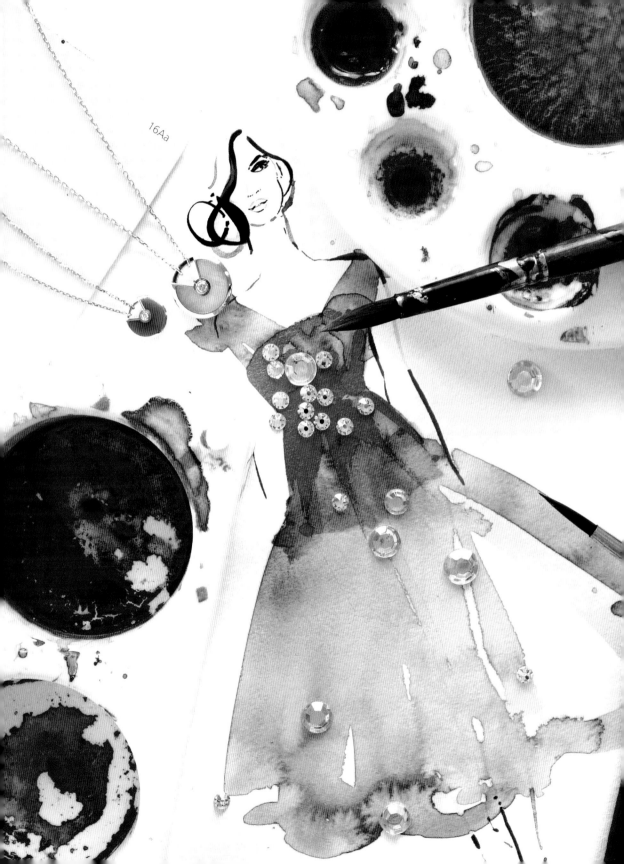

16Aa

all that sparkles is gold and more . . .

Jewelry is perhaps the most personal of all the elements of style. We wear it because of its meaning or the memories it evokes. Or we buy it because, well, sometimes we don't even know why—perhaps it speaks to us in a way that other things don't! Over the following pages, you'll see all of the bijous and baubles that I personally adore (you've probably guessed by now that I love anything that sparkles!). But you should collect and wear any gems and jewels that particularly spark happiness for you. Aim for a collection of pieces you'll keep forever. Even if they fit into a tiny box, they'll hold within them a lifetime of emotions. Talk about a treasure chest!

Fine jewelry

Whether spun in classic gold, silver, or rose gold, fine jewelry is timelessly elegant. Delicate strands—with or without dainty detailing—are ideal for the minimalist at heart. But you can also layer multiples together fabulously if you can't get enough of this type of adornment—try accessorizing within one tone family, such as all silver.

Cocktail ring

A statement ring with a colored stone is my eternal weakness—I never met a cocktail ring I didn't love! I particularly adore the pale stones of pink morganite, green amethyst, and blue aquamarine, set against yellow gold for the summer months, or embedded within white gold or silver for a cooler and more classic look that's perfect for winter or to match with work clothes. Cocktail rings are not about romance—they're jewels you buy yourself on occasion because, well, you deserve them! Wear them with wild abandon when celebrating, or for no reason at all.

Men's-style watch

A masculine watch looks incredibly sexy on a woman's arm. It's the accessory equivalent of a woman wearing a sleek black tuxedo suit; both suggest power and command attention. They look fantastic with a crisp white shirt and tailored pants (a nice contrast to the more elegant styles of watch that are suited to evenings or formal affairs).

Pearl necklace

Pearls may have a reputation for primness... but not in my book! A double-looped white-gold or silver necklace laden with oversize faux pearls looks fabulous with almost anything. First popularized by Coco Chanel, the look is as stylish as ever nearly a century later.

Costume jewelry

Not all of your jewelry has to be the real deal. Have fun with costume jewels—experiment with ephemeral styles and choose on-trend colors that will give your classic outfit an instant update.

A bangle or cuff

This statement style of bracelet exudes a certain cool confidence. A single structural cuff looks particularly powerful, while I also love how layers of slim bangles clink and clank and make their presence known! Stick to one tone of metal for the boldest effect.

Turquoise

No stone evokes such a breezy by-the-sea sensation as turquoise. This is your go-to jewel for summer holidays. Match it with salty beach waves and a light cotton dress; in the evening, turquoise stuns when accenting a white, flowing gown.

A statement necklace

This ornament for your décolletage comes in all sorts of styles and stones. Usually a shorter length, such a powerful piece nicely complements the neckline of a partly unbuttoned shirt or a low-cut top or dress. For the best bling effect, keep the spotlight on your necklace—it will only outshine any other jewels anyway!

A classic brooch

A beautiful vintage brooch is more adaptable than you think. Pin one over the top button of a white shirt, clasp it at the strap of a one-shouldered dress, or fix it on the collar of a tailored jacket. This little ornament might at first seem unassuming, but in fact it offers plenty of opportunities for creativity!

Chandelier earrings

Sometimes I am in the mood for serious glow, and these sparklers are genius for adding extra luminosity. Surprisingly versatile, chandelier earrings can be worn with most everything from beachy waves and boho dresses to slicked-back hair and a minimalist suit. As with any statement piece of jewelry, I usually make these earrings my sole accessory focus.

Random acts of kindness are also ones of joyfulness! Tell a stranger how lovely her dress is. Compliment a chef or barista. Let an intern know how impressive she or he is. You can't help feeling good when you put some supplementary goodness into the world.

Jewelry: an artist's view

You need not be an artist to appreciate the artisanal loveliness of jewelry, the endless ways in which shimmery strands and prismatic gems can be woven or melded together as one. As a watercolor artist, I'm especially smitten with semiprecious stones. Mother Nature must have surely taken out her watercolor kit when she created these crystals and gems! Aside from the variations of pastel and jewel colors to choose from, there is also an array of variation in sparkle and clarity to look for. Not every jewel has to be bright and shimmery. For those who appreciate something softer and more low-key, look for gems like black onyx or shades of "smoky quartz." For inspiration, I adore the challenge of painting all kinds of baubles, with their glimmering facets and ethereal hues.

It's enticing when jewels have an heirloomlike preciousness to them, when I can picture them being cherished one day by, say, a great-granddaughter. I swoon over the ornate jewels shown in portraits of Renaissance and rococo ladies, and I like to think of antique jewelry as a form of art I can hold in my hand (or wear on it!). Similarly, jewels that already have a history of love are enchanting. An antique bijou isn't only special for its uniqueness, but also for the way it glimmers with a mysterious past. We wonder, where and how was it worn in bygone days? When I'm on vacation, one of my favorite things to do is shop for antique jewels, and inquire into the stories of each piece. On a recent trip to Poland I spent hours sifting through vintage stores hoping to find my next gem. Finally my eyes lit upon a darling rose gold ring from the 1940s—it was just waiting for me to give it a shiny new lease on life!

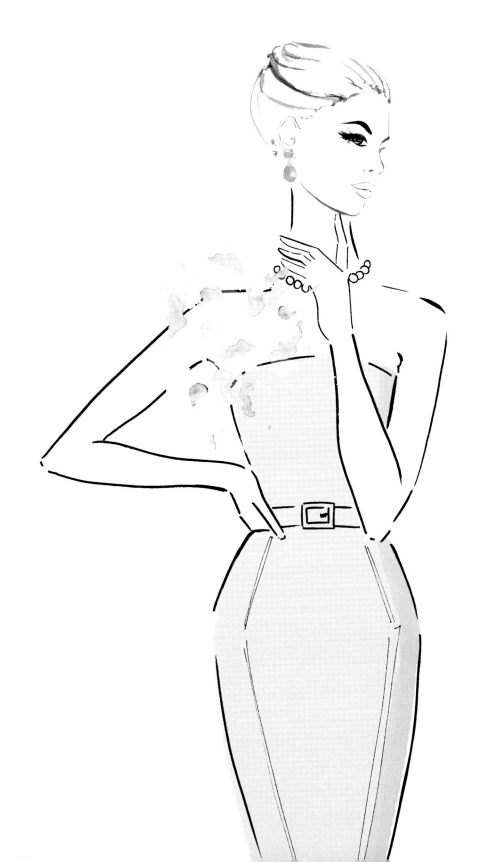

Calming and creative ideas

Why not create a vignette display for your most precious jewels? A small open tray in gold or silver grouped with flowers and a piece of art will not only allow you to see your most special pieces, but will add a reflection of light onto them, too. Position the grouping at a spot in your home you walk past when getting ready so you don't forget to add a touch of sparkle for those special occasions. You might wish to invest in a dedicated jewelry box with a glass top to protect your pieces.

BEAUTY JOY

creating your own
version of "beautiful"

Just as there is joy in discovering your own sense of fashion style, so too is there great satisfaction in deciding for yourself what is beautiful to you. And the confidence to claim your own individual beauty will always be in style.

It's wearing that bold red lipstick with no apology. It's having a pixie crop when everyone around you is sporting long locks. It's wearing no makeup at all if you feel confident without it—or a full face of makeup if that's your preference. It's indulging in a ritual of self-care for your skin and maybe some makeup experiments when in the mood, even if you are mostly staying at home. It's the exhilaration of choosing what makes you happy, and staying exactly true to that.

Parisian thoughts on beauty

True beauty comes from growing into yourself. Women are often led to believe that beauty fades with age—that beauty must go hand in hand with youth. But during my time living in Paris, where my favorite activity was to sit with a coffee and croissant and watch the world go by, I couldn't help but notice the stylish women "of a certain age" who strutted along the streets. They turned heads, and they knew it. Their power was in their self-acceptance, in their confidence, in feeling great in their own skin. It made me realize that beauty is as much a state of mind as it is a collection of creams!

The most important building block for beauty is skincare and, here again, I want to applaud Parisian women, because they consider facials not as a treat, but as something to be simply ticked off the to-do list—like paying a gas bill. "A facial is not a luxury, it's a necessity!" a lovely French lady in my apartment building once told me. "No amount of makeup will matter for me if my skin isn't in good shape," she added. This is the common thought in France, where more money is generally spent on skincare than on cosmetics. Take that as handy inspiration (and justification) if you can't remember the last time you booked a facial for yourself! I always recall this soigné madame in the stairwell whenever I feel any hint of guilt about getting a beauty treatment!

In between facials, make sure to cleanse, mask, moisturize, and protect your skin with your favorite lotions and potions. Devote time every morning and night to do so. After all, pampering your complexion is as much about self-care as skincare—it will calm your senses and enhance your well-being, which will in turn give you even more of a gorgeous glow!

Parisian women also made me see how important confidence is when it comes to makeup. Having good skin is part of that, sure. But it's also a positive attitude, seeing makeup as a chance to express yourself (rather than simply a way to hide flaws). Parisiennes like a strong look, and they don't

If injecting little bursts of joy into
your daily life is proving tricky,
try writing it into your to-do list.
Seriously! Every morning, when
noting down such tasks as "go
through inbox" and "pay electricity"
and "walk dog" also add "do something
joyful!" That could simply mean
sitting in the park to eat your sandwich
or reading a few pages of a new book.
The point is to remind yourself that
you deserve joy every day.

hesitate to go with it. The key is that they focus on either the eyes or the lips. This makes an impact without overdoing it. You still see the woman, not just her *maquillage*.

Many Parisiennes rock a dark, smoky eye from morning to night, and they apply it so immaculately that it always looks polished, never over-the-top. But the makeup look par excellence is red lips à la Parisienne.

I never used to have the confidence to wear a lip color bolder than pink; I always felt that my pale skin and light freckles would not sit well with a bold red lipstick, the way someone with a glowing tanned or dark complexion could. As a self-confessed introvert, I also worried that bright red lips would seem too "LOOK AT ME!" But in Paris I noticed so many women, of all ages and skin colors and personalities, wearing red lipstick, and carrying it off. I came to see that it's partly about which red you wear (more on this below) but even more so, it's a question of having the conviction that you can carry off a bold look because, well, you too can be bold when you want to be. Inspired, I made the decision to see red lips as a fun challenge, not something to fear. After all, it's only lipstick! Get a haircut wrong, and you might cry for weeks. Get the wrong lipstick, and you can always wipe it off and pass the tube to a friend.

In pursuit of the Parisian aesthetic, I ended up buying a deep shade of coral red. Before a soiree, I carefully layered it on and blended it in, while keeping the rest of my look fairly simple. I knew I'd appear different, but I was shocked at how different I *felt*. Confident and bold, not at all like my usual self, which is sometimes hoping to blur into the background. And that, right there, is the power of makeup! As the French women who inspired me must know, it's not a matter of being brave enough to wear makeup, it's knowing which kinds will make you feel braver, ready to tackle a tough day or a new job, a daunting meeting or a function where you don't know many people, a first date or a break-up…it's not called "war paint" for nothing!

So *merci* to Parisiennes for helping me add another element to my makeup repertoire…If you prefer to go au naturel—and let that gorgeous skin of yours steal the spotlight—go for it! Otherwise, have fun compiling a playlist of options that work for you.

beauty looks to try and secrets to know

Perhaps you have your signature beauty style sorted. Maybe you set off your tinted moisturizer with a smudge of eyeliner, a flick of mascara, and a swipe of beige lipstick, and you're good to go. And that's great! After all, who has excess time for experimentation on a regular day? Still, it can be fun to play around with your hair and makeup from time to time (when you actually have time!) just as you might shake up your fashion look every now and then. That could mean you go for bright green lids or bold purple lips…but it need not be anything radical! Turn the page for some can't-go-wrong beauty looks, along with a few beauty classics you'll love…

Bold red lips

As I've mentioned, red lips are a perennial favorite. Parisiennes might have made the look their own, but anyone anywhere can carry it off. It's the little black dress of makeup! Chic, sexy, time-tested. So the point is worth repeating.

You'll want to choose the tone of red that best sets off your skin and features. (Not sure whether you're more on the cool or warm side? Simply think of the red you like to wear in clothing, and go from there.) Since the art of makeup calls for balance, make your statement red lips the main focus and keep the rest of your face minimally made up with soft eye and cheek color, and dewy foundation.

Polished makeup + messy hair

Continuing the theme of balance... "Done" makeup paired with "undone" hair makes a fabulous impact. This is a very popular look in Paris, where women are loath to appear too "perfectly done"—a flourish of bedhead adds just the right amount of au naturel allure (even if they've spent time styling their hair to look unstyled!).

Pinkish blush

When our cheeks radiate with a rosy flush, we look healthy and more rested. We look like we're in love. We look...yes, joyful! As life gets longer and more complicated, our skin seems to glow less and less. Enter pink blush, makeup's lovely little secret for looking instantly happier, more full of life. From the palest ballerina-tulle pink to the most fabulous fuchsias, there's a pinkish blush out there for every skintone. Dust it softly onto the apples of the cheeks—I swear, you'll smile more because so many people will be smiling at you!

Smoky + pinky-nude lips

Blame it on Brigitte Bardot: this universally flattering look
will always be a classic. That's because it can be seriously
bombshell—as BB proved—but also rendered more subtly
sexy. Have fun playing around with effects. Work with
shades of charcoal and navy for a more dramatic look, or
tones of taupe for a daytime-appropriate version. Then
pick a lip color that is one shade darker than your natural
lip tone—but still light enough to keep the focus on those
smoldering eyes.

Concealer

Concealer is like your best friend who always has your
back. She might not be the most glamorous item (like a
sparkly eye shadow), but you can depend on her to bring
you back to life on even the dullest of days. Dab concealer
under your eyes to brighten them, just above and between
the eyebrows, and lightly around the mouth. Blend out
with a makeup brush and set with translucent powder.

Fixing spray

A makeup fixing spray is a beauty revelation—especially if
you live in a warm climate, or if you find your makeup tends
to "melt" by late afternoon. Post powder, a light mist of fixer
over the face will keep everything in order the entire day. I
discovered this gem of a product for my wedding day and have
used it ever since, whenever I know I need my makeup to stay
in place until evening.

The beauty of
an organized cabinet

You know when you find yourself rifling through old cosmetic products that are most likely out of date, searching for the one cherry lipstick you have somewhere in the jumble of it all? There is no joy in that! Make a pact to clean out your beauty items every six months, to reorder your lipsticks, and to wash all makeup brushes with gentle shampoo. Clear makeup organizers can be a saving grace if you need a little assistance in what to put where, offering a dedicated spot for every lipstick, blush, and concealer. These organizers make it a lot easier to locate each item and keep it in place than a travel cosmetic case does. There is always happiness in finding what you want when you need it, and having less clutter in general—a rule that applies to makeup as much as anything.

Know your break-in-case-of-emergency joy, the thing that is guaranteed to help lift you up, even if a little, when you are experiencing serious gloom. Is it bingeing on *Seinfeld* or *Sex and the City*? Baking a red velvet cake? Rereading *The Secret Garden*? Spending a day in bed cuddling your dog? Bouts of sadness are part of life, but surefire happinesses help us get through them.

Eau de Bliss!

Never underestimate the power of scent to transport you back to happy moments. When I was at university, dyeing my hair black and generally rebelling against the ways of the world, my favorite perfume was Issey Miyake Pour Homme. While it was quite a neutral scent, there was something about this fragrance that made me feel like a living-on-the-edge rule breaker! Even now, I am taken back to that exhilarating time in my life with just one spray. Similarly, a mist of Elizabeth Arden Sunflowers has me feeling fourteen years old again, whereas whenever I smell Lulu Guinness I feel that much more sophisticated, because it was what I wore on my first trip to Paris as an adult. My favorite bottle of memories, however, is Jo Malone Orange Blossom; it was the scent I wore on my wedding day, and it never fails to make me swoon all over again.

Wear perfume to evoke beloved memories—and create new ones. You can also, of course, use fragrance to enhance your mood…

Here are some ways to create fragrance euphoria…

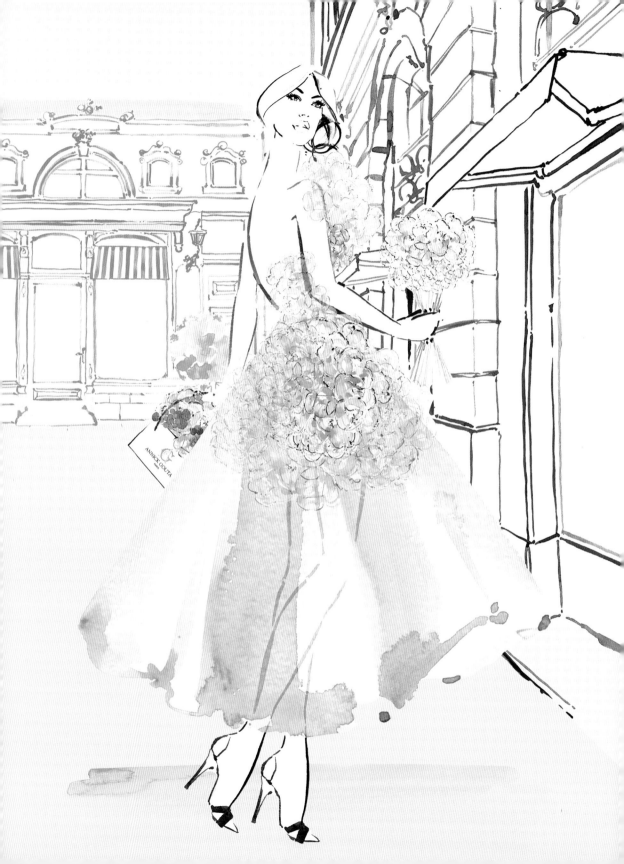

For a positive mood

On workdays when I need to stay focused and uplifted, I wear fresh, citrus-based scents. These tend to have a high proportion of top notes that fade relatively quickly, so you'll want to keep your perfume on your desk or in your bag and reapply every few hours. I also love burning or diffusing essential oils on my desk; the aromas of lemon, orange, spearmint, and grapefruit make for a subtle perk-me-up throughout the day.

For a romantic evening

Rich florals (think gardenia, tuberose, and rose) and powdery musks are fragrance's answer to a slinky silk gown: they instantly slip you into the mood for a glamorous night out. Even better, soak in a tub of water infused with the bath oil of your favorite scent; this will create a subtle base scent on which to mist perfume, a layering trick that will ensure a seductive *sillage*, or fragrance trail, that lasts all night.

For a beachside vacation

Look for a scent that creates an instant holiday mood with exotic or tropical notes such as jasmine, sea spray, monoi, mandarin, coconut, neroli, and citrus. I have a pure coconut scent that I only wear when I'm on a beachside vacation; it coordinates perfectly with a flowing kaftan and a fruity cocktail!

For relaxation

I tend to edge on the side of anxious, so calm evenings and good sleep are two of my biggest joys in life! I am much better equipped to face a day of work and deadlines after a lovely deep sleep. Lavender, jasmine, and vanilla all help to bring a sense of zen in the evening when I need to quiet my mind and ease myself into a state of rest. I also turn my phone off an hour before sleep time to wind down from work and a stressed world, and pop two drops of lavender oil on my wrists when I get in bed for an instantly calmer feeling.

Beauty: an artist's view

As an artist, you learn that beauty comes in countless forms; there is not one single definition of what is beautiful. This has helped me deal with the concept of beauty, as a woman. It must be said that the beauty industry puts a lot of pressure on us women! I try not to concern myself too much with the current trends in terms of cheekbones or lips or hair or physique… When you widen the lens to look at beauty from the point of view of art instead of fashion, you see that beauty, historically, is a constantly evolving and rather abstract concept. Compare the array of beauty showcased in paintings from the Renaissance to rococo to pre-Raphaelite periods, and you'll see what I mean. What was once considered the height of beauty all too soon morphs into another look altogether, which will change again as the world changes with it. Unless you're a professional model, it's daunting to try to keep up! It's much simpler to let go of whatever the current beauty trend happens to be, and follow your own sense of what is beautiful to you.

Philosophical thoughts aside…beauty is a lot of fun! You might not be surprised to learn that I view makeup a little like paint, with the face as another kind of canvas. I tend to use a few good-quality makeup brushes—keeping them as clean as I do my work tools—but you can also finger-paint your makeup on. Make sure you have a large, clear mirror, in good light, and when you have a spare hour or so, experiment with various colors. Just as a red lip can add a jolt of energy to your face, so too can a pop of magenta or orange. Or a wash of pastel will light up your eyes just as a streak of a rich jewel tone will pick up the color of your irises. Play around with textures, too: blend shimmer creams into your foundations for an illuminating effect, or dust matte bronzer across the face's high points to give you a holiday glow. And blush might at first seem scary, but when you get the placement and intensity just so, it's one of the most effective ways to infuse the face with a joyful glow! (Even if you had the worst sleep of your life the night before.)

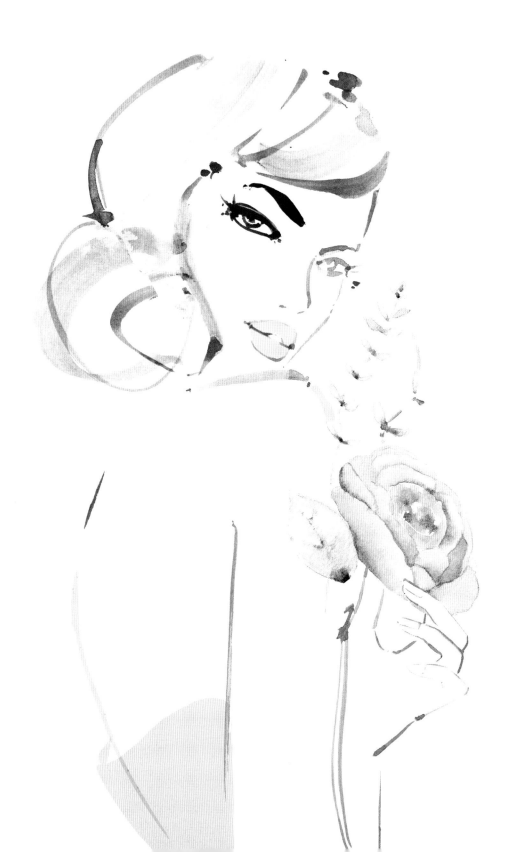

Experiment with your hair, too…Go crazy with your waves. Style a perky high ponytail. Tie a headband over long, satiny, swishy hair. Add a cute clip to a crop cut. Try sweet braids or a ballerina bun…Embrace your curls as your best feature. Or simply knot up hair you're too busy to style, and turn a bad hair day into a great one by wrapping on a brightly printed scarf.

Play with as many hair and makeup styles as you like. Or just stick with one signature beauty look. Remember, you are in charge of your own unique beauty. Enjoy yourself, and make no apologies for the look that you love.

Look in the mirror less!
By all means, enjoy your time
at the looking glass every morning
as you lovingly apply your creams
and have fun with makeup.
But then get on with your day
without fretting about needless
worries; focus on how you feel
rather than look. It's a wonderfully
liberating way to go about life!

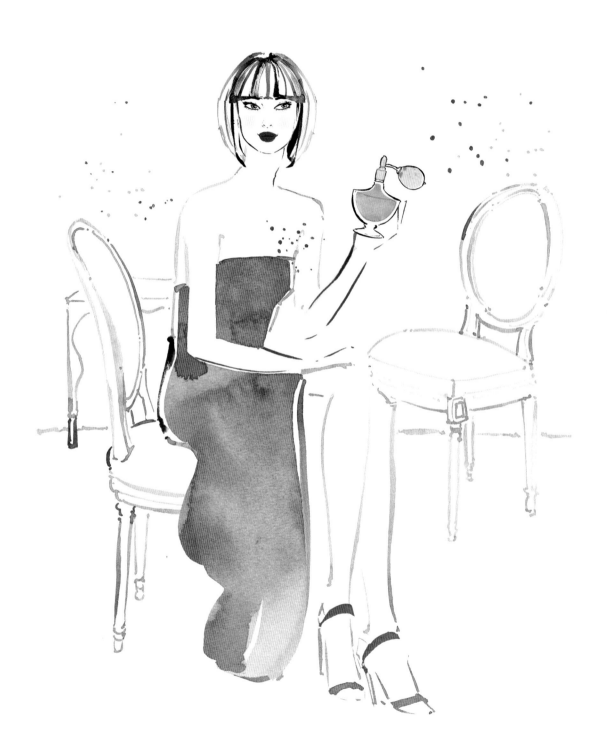

Calming and creative ideas

Try painting pretty perfume bottles like these in watercolor. You will need only the simplest set of watercolor paints, sheets of watercolor paper, and one point-tipped brush. Start each section of the perfume with a watery "wash tone" and then add pops of a deeper color into each corner of the wash while it's still wet. (The nifty thing here is that the watercolor formulation will do the painting for you!) Make sure to paint one color at a time and wait until it's dry before moving onto the next; this will ensure that the colors don't bleed into one another. You can come up with your own perfume designs or pop onto kerriehess.com to download the exact sketches seen here.

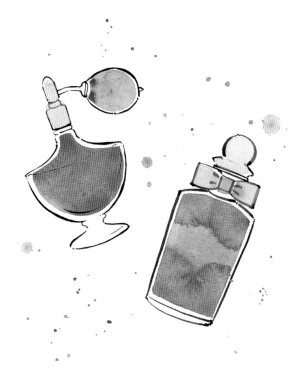

4

joy in
TRAVEL

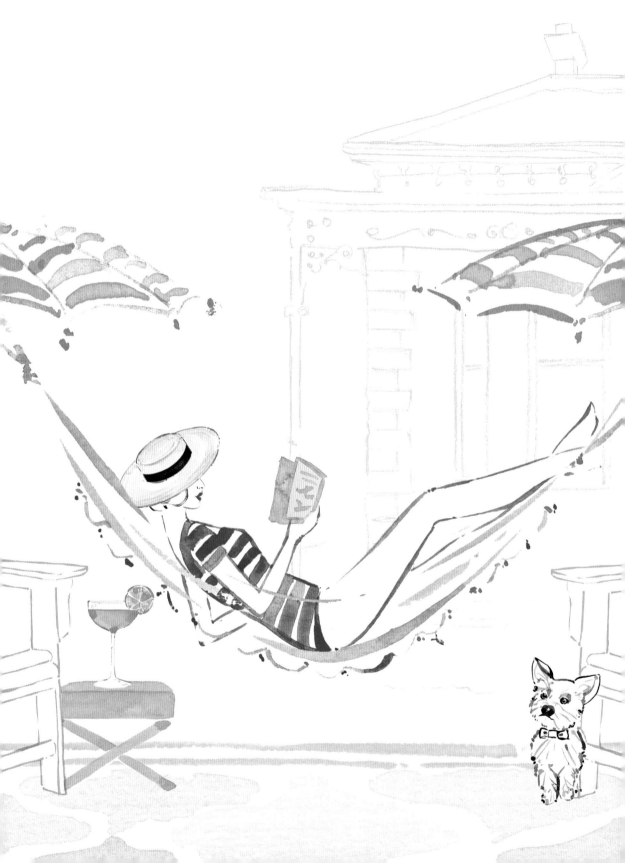

the pleasure of vacations and staycations

Many material things are lovely and covetable (this book is full of them, after all!), but for me there is so much more pleasure to be had in a wonderful experience, and the time to simply switch off and let our minds wander—a time to suspend reality. We don't have to worry about deadlines and bills. We're totally in the moment with ourselves, our family, our friends. And so we make the most of, and savor, every minute. I love the way that, later on, remembering how relaxed and cheerful you felt instantly puts a smile on your face. You can never have buyer's remorse over something that has the power to do this magic trick. Going on vacation or indeed a staycation is like buying beautiful memories that will last a lifetime.

That holiday feeling is all about living in the present moment (so much so that we often forget what day it is!). And with the world's current limitations, the trick—even if you're having a vacation at home—is simply to take yourself out of your usual routine. To tap into that holiday headspace where you can forget about laundry, e-mails, and deadlines. You'll feel that tension in your jaw relax and your shoulders drop naturally—that's the beauty of vacation.

Finding joy and relaxation in your own backyard

As we have all discovered in recent times, it's not always possible to travel far and wide, whether for reasons of time or budget or world events, but there are so many different definitions of a vacation than weeks of exotica-filled adventures. There is, of course, the staycation—the perfect getaway when you can't, well, get away. That might mean in your own backyard literally (more on this follows!) or within a few miles of it. Perhaps it's a weekend away in a bed-and-breakfast on the other side of town, or maybe it's a few days of road-tripping around the countryside or along the coastal road in your own town. The "where" doesn't matter so much as the "why"; the point is to experience life from a different perspective. To escape from any worries of reality, and simply have fun for a while, because it's good for the soul.

Plan your staycation as you would a regular getaway. Once you've locked in your hotel or rental, research the local theater's offerings, and book whatever piques your interest. If theater or musical events aren't in the cards, read up on local cultural events and other activities you can enjoy outdoors. Make sure all of your current work or school projects and to-dos will be sorted well before your departure date, and then set an out-of-office message just as you're about to go (always a joyous task!). Pack what's appropriate for your destination, as well as a fancy outfit. Because what's a holiday without a couple of great nights out?

You could dine at the most raved-about restaurants when that's an option, or indulge in your takeout at a scenic spot, from your favorite restaurant or from somewhere you've never tried but have been wanting to. Or simply aim to try food you don't normally eat. Do you have a go-to vacation cocktail—perhaps a refreshing gin and tonic, or a salt-rimmed margarita? Order it (to go, if need be) to get you in the mood, and toast the fact that you're treating yourself to a few reality-free days.

Enjoy haute cuisine if it's your thing, but don't forget that vacations are also about discovery, about being "out of the office." Even if you're in your

own city, explore another side of it by visiting a quirky museum or local attraction you've never managed to get to over the years.

And if your staycation is quite literally in your backyard you can make it transporting. If the weather is balmy, set up a tent and some hammocks outside. You can keep it rustic and simple, but if glamping is more your scene, make the decorating part of the fun, filling a fabulous large tepee with gorgeous cushions and throws, and creating extra atmosphere with glittering twinkle lights and glowing candles. Have a picnic basket and cooler brimming with treats, or order in meals to eat as you loll about, listening to a soundtrack of chirping insects and chill music, and remembering that a vacation is as much a state of mind as a place.

The simple act of breaking out of your normal routine will completely change how your mind and body feel. Make a point to sleep in, and not check e-mails (get that out-of-office reply set up!). Have *pain au chocolat* and coffee for breakfast as you might on holiday. Do the things you may not have time to do at home during a typical week, such as taking an afternoon nap or reading on your sunlit balcony. Slowing down and disconnecting makes it easier to notice and take pleasure in what's around you (or to lose yourself in a great book).

ways to treat yourself during time off

Here are some ideas to perk up your days away from work…including when you're staying at home or close by. (You can also enjoy them over a weekend or whenever you can make a little extra time!)

- Sign up for a short course. On anything! Calligraphy or cartography or carpentry! Learning and creating are two of life's greatest happinesses.

- Stash a picnic basket in the trunk of your car, stocked with plates, cups, napkins, cutlery, a bottle opener, and a cute blanket (keep it there even after your days off!). You'll always be ready for a spontaneous alfresco feast—just add bread, cheese, and wine!

- Little is more joy-boosting than spending time with an animal—cuddling a puppy, listening to the delicious sound of a cat's purr as you stroke its fur… If you don't have a furry friend, borrow someone else's for a day or night. Warm and fuzzies, guaranteed!

- Sure, we're happiest when we're healthiest, but sometimes we crave good, old-fashioned comfort food, the kind that made life worth living when we were kids. So don't feel guilty about indulging in your food past during time off…a steaming fondue, a bowl of mac and cheese, a whipped-cream-piled-high banana split…it's all food for the soul!

- Spend time going through your digital photos and printing out your favorites. You'll have lots of happy memories as you look. Store the prints—along with old family photos—in a lovely box on your coffee table. Each "lucky dip" into this treasure chest is guaranteed to bring back gorgeous memories or fascinating stories.

- Fill your living space with greenery, dotting plants in colorful pots throughout your house or apartment. It will connect you to nature as well as enhance air quality and the general sense of artistry in your home. If you can do this before your days off begin, it'll make that time all the nicer.

- If the season is right, nurture a lavender garden, even if it's just in a planter box. It's a lovely little slice of southern France! Plus, the scent will help to both de-stress your senses and boost those feel-good endorphins.

- Buy yourself a beautiful vintage crystal jug and fill it with a scoop of ice and with fresh filtered water every morning, infused with whichever fruit tickles your fancy that day: strawberries, blueberries, lemons, limes… It will look gorgeous on your table, for one! And you'll feel refreshed and uplifted as you sip your way through it during the day.

- Think of the book you loved most when young. Was it *Pippi Longstocking*, *Alice's Adventures in Wonderland*, *Anne of Green Gables*, or *Where the Wild Things Are*? Buy it for your grown-up self and spend an afternoon reconnecting with younger you, and seeing the world as you did when you were wide-eyed with wonder.

the excitement of new experiences

There is still good reason to dream about the thrill of discovery and future adventure, about the excitement of meeting fascinating people, seeing new art and architecture, and tasting exotic dishes. Even if they are just on your moodboard for now, allow yourself to enjoy your fantasies. A sojourn in Italy one day is on my own pinboard for this very reason!

And you can still make a point to travel somewhere inspiring when you can, even if it's not far away or it's only for a few days. It's far more beneficial to take shorter holidays regularly than to save up for a big one every ten years or so, because of how little hits of joy increase your well-being. Think of it like your daily dose of dark chocolate—one square every day versus an occasional box of chocolates…I know which I'd prefer! You could say that time is the ultimate luxury, and it can be spent close to home with the same soul-reviving effect.

When travel is once again part of our lives, give yourself permission to go where the wind blows you. This is coming from a serious planner. I love to know in advance where I will enjoy shopping, eating, and wandering, but I make myself leave wiggle room for spontaneity. Time for serendipity. The opportunity for making discoveries of my own…This is how I came across the perfect little London café for whiling away a rainy afternoon. A wrong turn near the Louvre took me to a divine vintage boutique that I got lost in for hours. And an afternoon devoted to impromptu strolling led to finding what is now a cherished gelato spot in Rome.

Keep your eyes open for new discoveries close to home, too. This is how I recently came across little aqua fairy pools (natural tidal rock pools that are perfect for swimming) while wandering through the coastal national park about an hour away from where I live. Another time, I stumbled upon a quaint seafood market after a beach stroll, leading to a picnic of fresh oysters at sunset. And en route to a nearby destination for a few days away, there was an impromptu stop for some local produce at a farm where my husband and I ended up staying for lunch and a glass of wine…

In other words, leave room on your itinerary for new experiences, for what you never get to do in real life, even in your own city. Try devoting much of your holiday to discovering another culture or watching the world scurry by, as you sit in the sunshine for an early-afternoon *aperitivo*. Grand monuments are all well and good, but small moments also make for lasting memories.

Add to bag

A few little luxuries and necessities to make your voyage a little smoother for those future dream travels or a local getaway that is still a joy to plan for:

Cashmere or wool socks for a long flight or a comfy touch wherever you stay.

Calming lavender oil for flying and sleeping well at your destination.

A soft pashmina or scarf that can be used as another pillow for a long flight or a light throw for a chilly evening.

Slippers and a soft wrap.
(I love feeling cozy when traveling!)

A new perfume. Infuse happy memories in it by wearing it on vacation. Or buy one in a perfumery, the flagship store of the perfume's brand, or a lovely boutique.

Books in whatever genre you prefer. For vacation time, I love nothing more than a mix of psychological thrillers and swoonworthy romance novels!

Vacation style staples

If you can swing it, try to take carry-on luggage only for a flight, or an overnight bag instead of a big suitcase for closer travel. When you're headed on a short stay, this makes for a more joyously lighthearted holiday! I revel in the feeling of packing light, which sets a beautifully free and easy tone for a few days away. These are some of my favorite staples that can be worn multiple times when traveling:

- A little black dress. Accessorize it up (high heels and a beaded clutch) or down (flat sandals and a cross-body bag) to suit any new situation or occasion in which you might find yourself.
- A trench coat. The perfect suit-all cover-all for a city stay.
- A white shirt, dark denim jeans, and ballet flats. Right here is your foolproof travel outfit.
- A crisp T-shirt in white, gray, or black, and a printed skirt. Another surefire outfit. Add flats or heels and you're all set.
- One lightweight dress that could be worn for an unexpected evening out…A just-in-case dress!
- Scarves and wraps. Lightweight wool and cashmere for winter, silk and cotton for summer, printed and pretty for Paris!

The feel-good factor of heading outdoors

Whether you are pinning images of dream travel or planning a mini break to the beach or countryside, I swear you can have as much fun preparing for a vacation as being on one! And having a nature or seaside stay marked into your calendar is sure to get you through the dreariest workday. It's the sunny light at the end of a dark tunnel! There is so much joy, too, in delayed gratification, the old-world ritual of saving up for something special. You can even tap into the scents and sounds of a vacation by simply noticing the beauty of nature in the everyday. Stop to smell the blooming roses in your local park or nearby countryside. Linger under a shady tree during summer with a good book and a chance to breathe. These little moments can feel like a farm stay close to home.

And there's also joy in visualization. Most nights, once in bed, I like to play a little mind game with myself, inspired by whatever vacation I have booked that year—even if it's a weekend away somewhere local. I close my eyes and imagine myself already there. I try to sense the new aromas and sounds around me. I picture myself reading a book, not a care in the world (and not a deadline in sight)…and most likely a spicy margarita in hand!

Visualizing myself transported to vacation mode helps my body completely relax and fall asleep in the process. And considering that our imagination is as important for our emotional well-being as our reality is, this little visualization exercise can be powerful if you do it on a daily basis. I often wake up feeling relaxed, too, as though I've recently been on vacation. Not that it beats the real thing, of course! And the thrill leading up to it…

Stop and smell the roses
by paying attention to the flowers
newly coming into blossom
every week. Look at how they grow,
notice how they smell as they bud
then bloom then wilt. It's a gorgeous
way to practice mindfulness,
as well as to feel at one with the
rhythm of nature.

Planning tips

Some ideas to keep in mind when planning your next adventure:

- Change your phone wallpaper to a dreamy image of your next holiday location the second after you've made the booking. From then on, every time you look at your phone there'll be a little reminder of the vacation joy to come!

- Research your destination, looking up the best and quirkiest spots to keep in mind. Start an album on your phone and fill it with screenshots of restaurants, cafés, and things to do, or anything else that takes your interest while you're scanning websites and social media feeds. I don't recommend overplanning a trip, but having a few places already in mind will lead you to some sure bets, while—when it's safe to be spontaneous—leaving the rest to those little gems that are found by chance.

- Ask friends who might live or have lived at your travel destination for insider recommendations. It's the local haunts that are often the best! You could even pop an e-mail over to your hotel or phone them and ask about places to visit in town and the possibility of their making a booking for you.

- Allow yourself to dream about, plan, or even—if you can— book your next holiday as soon as you get home from the last. Having something to look forward to is so important when navigating the routine of everyday life, family, work, and deadlines. It doesn't need to be a first-class trip to Paris! A weekend "staycation" at a hotel in your home city is a joy to have on the horizon.

beachside essentials

Tucked away in my wardrobe is a section of clothing I like to refer to as my "cabana wear"…candy-striped maxi dresses, silk kaftans in swirling prints, intricately jeweled sandals…They make me happy for their association with a sense of relaxation. There's something about being on holiday that makes you want to dress in bright shades. A little like that summery scent you always wear on vacation. And while your next getaway may not be to far and wide places, you can still pack some beachside glamour and sunshine into your suitcase or overnight bag to tap into these festive feelings. Close your eyes and hear the soft sound of the waves and breathe in that salt air. You may be close to home but the feeling of being by the sea is still one that brings back childhood memories and a sense of calm.

In the weeks before a trip I love to start putting aside things I'll take, popping them into a favorite tote in my bedroom. It's another way of reminding myself daily of the holiday happiness to come. If I bought something special in the months before, I hold back from wearing it until I'm away—and this infuses a little more joy into that piece. I recently did this with a pretty yellow dress—all florals and frills—and it will forevermore make me smile for the memories it evokes of Paris in summer.

Only pack the items that make you feel like your most relaxed and happy self! Here are some of my personal favorites…

An oversize white shirt cover-up

Ideal for the beach, this is also great to wear with a maxi skirt in the evening. Choose a wrap-around that ties at the side for an extra hint of effortless chic.

A broad-brimmed hat

Stylish and sun-safe is a win-win. Light colors look classic and help keep you cool; for fun, pick one that's accessorized with a ribbon in any color or pattern you like.

A kaftan or maxi dress in printed silk

Perfect for poolside lounging and Prosecco sipping. Wearing one makes me feel fabulous, not to mention a million miles away from being in work mode at my desk!

Metallic heels for evening

Choose a pair that are comfortable enough for evening strolls by the beach. (Leave those skyscraper heels at home unless you won the genetic lottery and can genuinely walk all night in them happily... in which case, I envy you!)

Yellow-gold accessories

Something about a touch of yellow gold with a silk dress creates
the perfect feeling of laid-back luxe I always want when on holiday.
Think Slim Aarons resort vibes. Either costume jewelry or the
real thing!

Palazzo pants

Nothing feels more Italian Riviera than white high-waisted
palazzos in summer. Try them with a silk shirt or camisole in
a bright shade or print.

Jewel sandals

These vacation must-haves will go everywhere with me,
from wandering through summer markets to dining and
dancing by the beach.

A turkish towel

It's pretty for the beach or a picnic and is less than half the
weight of a regular towel.

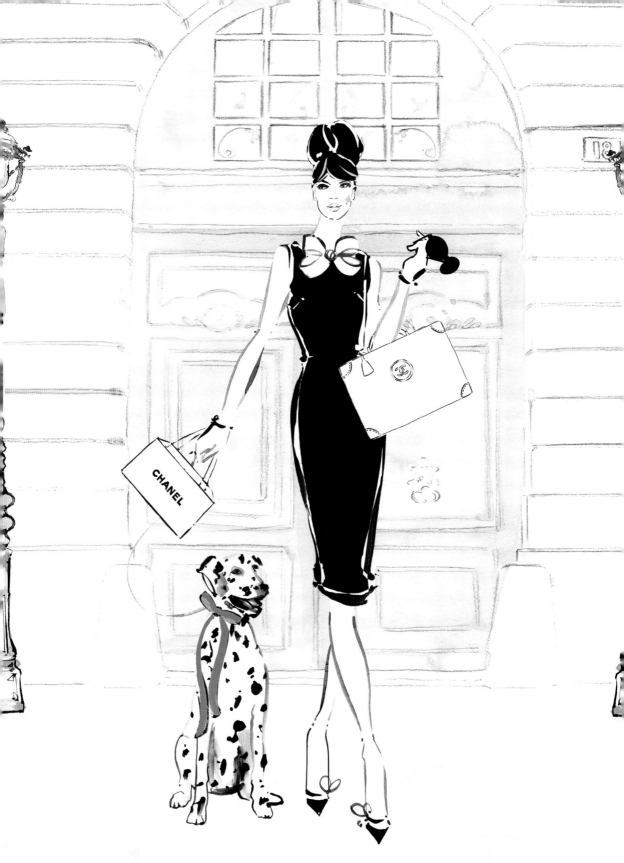

Travel: an artist's view

For me, little is more delightful than painting while on vacation. After all, it's two of my greatest loves—travel and art—combined for double the joy! I always pack a small set of watercolor pigments, paper, and brushes, and carry them with me for those spontaneous moments when I can capture a new setting with paint.

Whether you're a professional or amateur artist, painting a series of vacation vignettes is a wonderful way to experience a new destination and to create special souvenirs for yourself or your loved ones. Get into the habit of packing a pencil for sketching, a mini set of watercolor paints (a tray of dry "pan" paints is compact enough to fit in your pocket!), and a small watercolor sketchbook. Or start a "visual diary" to accompany you on all your travels; imagine how special this will be to browse through in decades to come, how it will transport you and your senses right back to a French riverside picnic or a frangipani-strewn tropical beach or rustic farm stay.

The key is to find the time during each busy travel day to sketch and paint—not always easy when it's challenging enough to make time just to pen a postcard! But start to forge the tradition, and it will eventually become habit. You'll instinctively look for, and find, a relaxing and picturesque spot—a flowering park just begging to be celebrated in a pretty nature scene, or a terrace café looking out to an intriguing facade or monument…Travel has a way of bringing out the artist in everyone, if you let it. And once you're home, all of those delightful inspirations—line, color, and texture—will travel back with you, ready to infuse your work, your sense of design, your imagination. All you need to do when traveling is keep your eyes open…

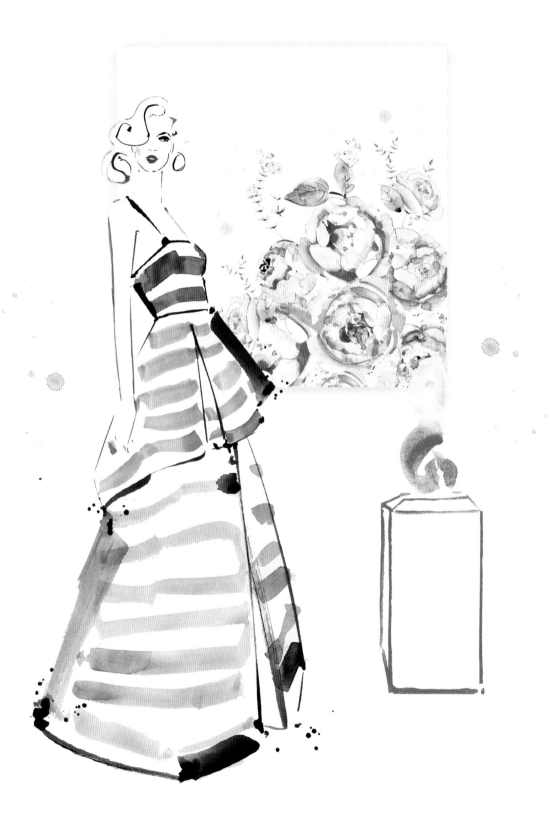

Calming and creative ideas

Visit a local gallery that you've not yet made the time for, and soak up the creative culture of your own city. We often consider museums as places to visit when traveling, but why not support the art of your hometown? Or head to a nearby park and sketch out some local florals (which nicely doubles as a little outdoors meditation). Use the same sketchbook whenever you go so that, later on, you can look back and see how your drawing process and style have evolved over time.

5

introducing...

THE JOYBOARD!

the joy of drawing delightful things into your life

There is something magical about the power of visualization, starting by committing a list to paper in order to help manifest the objects, milestones, and experiences you want in your life.

One step further is creating a visual moodboard. Or, in the spirit of this book, a joyboard! The simple act of pinning inspirations to a physical board that you will see every day can be incredibly powerful. It pleases the eye and uplifts the spirits. It's like a window to your dreams, a framework for your ultimate future.

I created my first joyboard back when I was a child and learning to paint the things I loved. Some were items I wanted in my life at the time, such as a pretty dress or a sparkly pair of shoes. Others were simply those things that made me happy to look at…animals, blossoms, rainbows…It all made for lovely wallpaper, too! With my grown-up joyboards, I've found that I can experience a similar heart-fluttering satisfaction out of gorgeous images of beautiful things…a picture of an Hermès bag, for instance, gives me so much pleasure that I don't feel the need to actually own it! Images of flowers, too, can be as soul-soothing as the real thing.

But a joyboard might not be all about material things. You might want to include symbols or images of love and relaxation to denote "more time with family," "less work on weekends," or perhaps a renewed relationship with a family member who has drifted from your life, or just more time for self-care. That's the thing about a joyboard: it's little snippets and snaps of whatever will make for a happier life.

Moodboard manifestations

I have had so many surprising experiences over the years with my own moodboard imaginings, some of which I honestly didn't expect to happen. One such incident was in 2011, when I was living in Paris…. It was a quiet and rainy afternoon, and I was at home painting in watercolor, inspired by the colorful and upbeat designs of Kate Spade. I remember pinning one of my sketches to the moodboard above my desk—it was of a woman in a polka-dot skirt, with a tiny puppy. I posted my "Kate Spade–inspired" image to Facebook without further thought. A few days later, I received an e-mail from the design team of Kate Spade New York about meeting in Paris to discuss collaborating on a project. I looked up at my moodboard and wondered just how much the pinning of the image both on social media and on my personal board had to do with the project that followed: creating a custom range of illustrated fabrics for one of my favorite brands. In all honesty I think that a combination of putting what you love out into the universe and pinning it on an actual board can be powerful in manifesting that very thing.

Another memorable moodboard happenstance took place in 2016, when I affixed a little corner of packaging from my favorite champagne (Laurent-Perrier Cuvée Rosé, probably the world's most iconic pink champagne) to my board. There was something about the shade of pastel watermelon pink and the ornate French label that took my fancy. And, as you might have guessed, six months later I found myself in a meeting with none other than

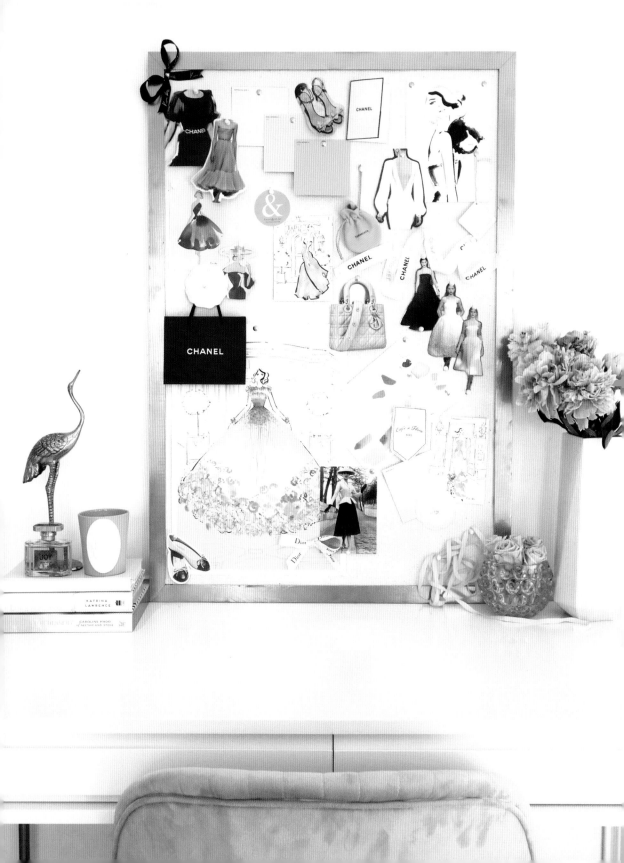

Laurent-Perrier, where I was asked to create a signature illustrated box for the French house. It would be the first ever collaboration for the brand in any country in the world. (Only later did I find out that this was since 1812!)

These moodboard materializations are but two of many over the years. I've also found that my pins have helped me hone my decorating style, realize my travel fantasies, and focus my vision on achieving work dreams and personal goals.

I particularly like to create a moodboard at the start of a new year. Last year I was dreaming of a family vacation in Hawaii, so an image of the island was front and center on my board. This was a reminder not to let the year slip by without planning the thing that meant the most to me: memory-making with loved ones. Another picture was of an art piece that became part of my online Masterclass in Painting—my first venture into the online teaching space, and my most important (and scary) project of the year. It also turned out to be my most personally rewarding.

There is so much power and romance with a physical joyboard, but you can create a digital one too with Pinterest. Start a new board, named "Joy" or something similar, and simply pin whatever inspires. In a practical sense, Pinterest is also a wonderful resource when decorating. Try creating a dedicated "Might Buy" board (this may be one you want to make secret) and add anything that captures your imagination. Then you can look back and compare items. I saved seven different pendant lamp options when looking to light a very specific space in my home. Comparing all the costs and sizes from my laptop, when curled up on the couch in pajamas, made it so much simpler (and more joyful!) to decide than if I'd trekked from store to store.

Something that makes your life prettier but also easier? That's joy to me!

Some ideas of what to pin on your joyboard:

- **Home and fashion style:** What would you have in your dream house or dream closet if money were no object? Even if the original version is out of budget, you might still be able to take inspiration from your pinnings.

- **Career aims:** What are the ten things you would most love to achieve when it comes to work? Out of this list, pick and highlight only your top three as the sole projects to focus on this year and cross out the rest. That way, you will feel less overwhelmed to be faced with everything on the list and will be more likely to achieve and complete the ones most important to you. Once those three have come to life, you can move on to the others!

- **Personal goals:** What are the three most important things to implement that will affect your life and long-term health? Even small incremental changes, like thirty minutes of extra sleep each night or ten minutes of morning stretches, will enhance how you feel every day.

- **Reward ideas:** Do you need a little help when it comes to motivation? Add images of special treats with which you could reward yourself on the completion of work projects.

- **Travel inspiration:** If your life flashed before you, where would you wish you had visited at least once?

- **Just because:** Anything that makes your heart smile. For any reason— or none at all.

Calming and creative ideas

At heart a moodboard might be a manifestation of your deepest hopes and dreams…but it can also be a lovely work of art! To create a suitably decorative frame, take a simple white pinboard and cover the front of the board with newspaper before spray-painting the frame in your favorite color. Gold, silver, rose gold, powder pink, sky blue, pistachio, lipstick red…the choice is yours. Once the paint is dry, remove the newspaper and start pinning your photos, or anything that's symbolic to you. It could even be that Parisian café napkin you've kept in a drawer for years! You can use simple thumbtacks, or you could try an array of bright or sparkly pins—or even old brooches—to make your board all the more special. Make sure to place your moodboard where you will see it each day—remember that there is so much power in a visual reminder of what you wish to attract into your life.

a final musing
on joy…

The word *joy* derives from the Latin *gaudia*, which means "expressions of pleasure" and "sensual delight." And the ancient Romans, with all of those petal-laden parties of theirs, sure knew how to revel in gaudia! For many centuries thereafter, joy had a certain gaudiness, or showiness, to it. When French designer Jean Patou launched what was then the costliest fragrance in the world—just after the Wall Street crash of 1929 that triggered the Great Depression—he called his floral frenzy of a scent…Joy. Despite the times, it was a huge bestseller.

We humans are hardwired to crave joy, especially during trying times. And that brings us to now, when the world feels anxious and fraught once more. But what has changed, I believe, is our definition of joy. We no longer feel that we need the world's most expensive perfume. Or anything splashy, really. Joy can be found just as much—maybe even more—in life's little things as in the big ones.

Joy might once have been as flashy a notion as a glittering necklace of multi-carat diamonds. Now, I can't help seeing joy more as a delicate charm bracelet—a lovingly curated collection of moments and memories and mementos that are meaningful to you alone. When I was little, I had an actual charm bracelet, and I'd adorn it with trinkets that were souvenirs of trips abroad—a mini Eiffel Tower, a sweet little Statue of Liberty, a not-so-big Big Ben…These days I know that while holidays are wonderful, you can also treasure the events of everyday life. Going for afternoon tea with your grandmother, taking time out for a long steaming shower, sitting in a park among blooming roses…

Stopping to smell the roses is a cliché, I know! And perhaps it's because the expression is so overused that we don't take it as seriously as we should, and we don't stop and inhale enough, both literally and figuratively. If there's one message I hope this book leaves you with, it's the soul-satisfying pleasure of slowing down and taking in life's small and delightful details.

Don't think you can't covet a decadently priced perfume that drips in pure glamour, or jewelry that sparkles like sunshine. If it makes you smile, that's great! As the previous pages have proved, I too have a knee-weakening passion for beautiful creations. Creativity is a joy, after all! To be creative yourself, and also to appreciate others' creative endeavors. A beautifully cut gown, an exquisitely bejeweled shoe, the perfect red lipstick, a gilded porcelain teacup…But your cup of tea can be anything at all, whatever warms your heart.

I hope I have inspired you to search out new sources of joy in your life, and the world around you. The particularly joyous thing about joy is that it's not hard to find, once you make the decision to look for it.

Joyfully yours,
Kerrie xx

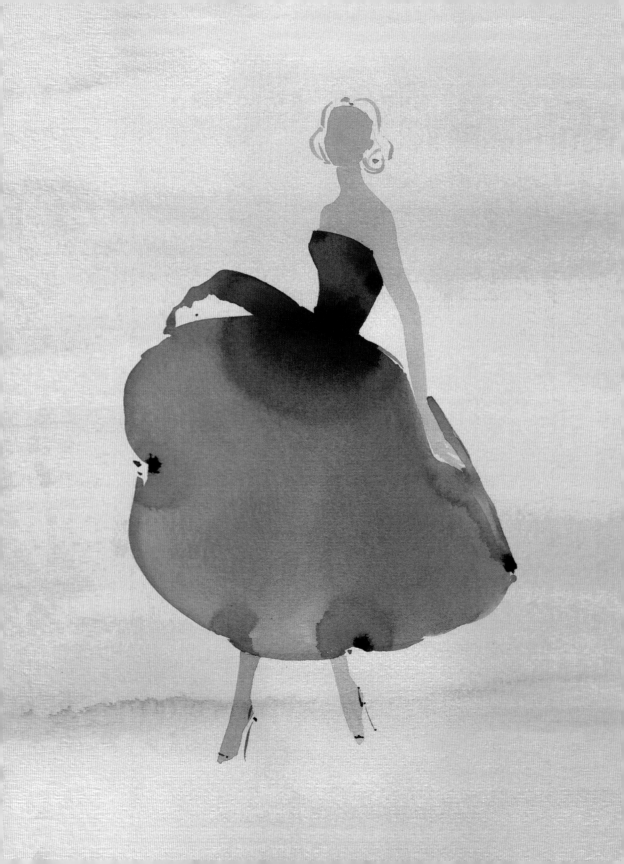

acknowledgments

I wish to thank the people in my life who have been part of the journey of creating this book and supported me along the way! To Peter and Marcel for often asking me how it's going after entire weekends and late nights painting and writing, and for always listening!

To Aliza Fogelson, Charles Miers, and the team at Rizzoli for believing in this book from the very beginning. Thank you, Aliza, for encouraging me to open up with my own personal stories throughout the book and for your infectious enthusiasm and insights along the way. You have been a dream to work with.

Thank you also to Katrina Lawrence, who helped me edit the text of the book and added so much sparkle to my words. You are equal parts ray of sunshine and pure talent. Thank you! We were destined to work together, having run into each other in Paris by chance so many times over the past ten years!

To Jennifer Beal Davis for designing truly delightful layouts and type around my words and sketches. You have visually brought this book to life! Thank you also to photographers Grace Alyssa Kyo and Mindi Cooke and stylist Tahn Scoon for lending their magic to the book.

And lastly thank you to three wonderful people in my life: to my mum and dad, Jan and Bill, for always believing in my creative pursuits in life, and for always looking for the best in everything and everyone. And also to Grace Cooney, for helping me choose the cover and for all of your support in life and in the art studio. I couldn't do it without you!

First published in the United States of America in 2021 by
Rizzoli International Publications, Inc.
300 Park Avenue South
New York, NY 10010
www.rizzoliusa.com

Photographs are by Kerrie Hess except on page 75 by Grace Alyssa Kyo and
on pages 83, 88, and 97 by Mindi Cooke (styled by Tahn Scoon).

Publisher: Charles Miers
Editor: Aliza Fogelson
Design: Jennifer K. Beal Davis
Production Manager: Kaija Markoe
Managing Editor: Lynn Scrabis

Printed in China

2021 2022 2023 2024 / 10 9 8 7 6 5 4 3 2

ISBN: 978-0-8478-6949-7
Library of Congress Control Number: 2020948507

Visit us online:
Facebook.com/RizzoliNewYork
Twitter: @Rizzoli_Books
Instagram.com/RizzoliBooks
Pinterest.com/RizzoliBooks
Youtube.com/user/RizzoliNY
Issuu.com/Rizzoli

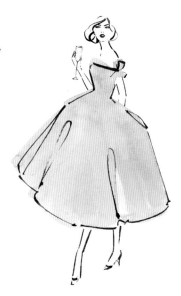